The Art of the Dot

The Art of the Dot

Advanced Airbrush Techniques

Robert W. Paschal

Robert Anderson

 Van Nostrand Reinhold Company
_____ **New York**

Library of Congress Catalog Card Number 84-25834

ISBN 0-442-27510-2

Printed in Hong Kong
Designed by Al Roberts Design Studio

Published by Van Nostrand Reinhold Company Inc.
135 West 50th Street
New York, New York 10020

Van Nostrand Reinhold Company Limited
Molly Millars Lane
Wokingham, Berkshire RG11 2PY, England

Van Nostrand Reinhold
480 La Trobe Street
Melbourne, Victoria 3000, Australia

Macmillan of Canada
Division of Canada Publishing Corporation
164 Commander Boulevard
Agincourt, Ontario M1S 3C7, Canada

16 15 14 13 12 11 10 9 8 7 6 5 4 3 2 1

Library of Congress Cataloging in Publication Data

Paschal, Robert.
 The art of the dot.

 Bibliography: p. 123
 Includes index.
 1. Airbrush art—Technique. I. Anderson, Robert,
1945– II. Title.
NC915.A35P374 1985 751.4′94 84-25834
ISBN 0-442-27510-2

Contents

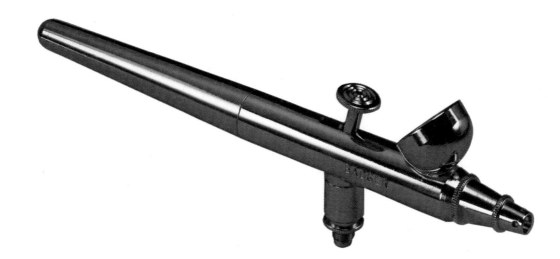

0-1. Badger Model 100 GXF Airbrush.

Acknowledgments

Airbrush Digest Magazine
Al Roberts Design Studio
American Artist Magazine
June Anderson
Artistic Airbrush
Artronics, Inc.
Badger Air-Brush Company
Blaise Batko
Ann Benson
Binney & Smith, Inc.
Paul Bond
Ginny Brush
Robert Burger
Hilo Chen
College Art Association
Rip Cronk
Fred Danziger
Roland Dempsey
Susan DeNoble
Ellen Denuto
The DeVilbiss Co., Ltd.
Lelon Dietz
Charlotte Dinger
Don Dixon
Susan Ebbert
Don Eddy
Maureen Ellis
William Ellis
Gail Faccidomo
Fat City Cafe
John Fennell
Audrey Flack
Pat Frank
Fredrix Artist Canvas, Inc.
Frisk Products, Inc.
Michael Gallagher
Arie Galles
Darlene Genglebach
George Green

Tony Gregory
Al Grove
Dan Gunderson
H. N. Han
Harris & Stiles Co.
Wendy Hatch
James Havard
Heller Gallery
Ruth Hardinger
Alan Hewson
Bonnie Hofkin
Thomas Hubert
Ron Hudson (Air Studio)
Jane Hurd
Max Hutchinson Gallery
Isis Gallery
Jack Gallery
Rixford Jennings
Johnson Atelier
Layne Karkruff
Susan Kingsley
Theresa Kraft
Gregg Lefevre
Scott Lewczak
Louis K. Meisel Gallery
Rosemary Ishii MacConnell
Gail MacGibbon
Peter Mackie
David Mascaro
Medea Trading Co., Inc.
Paula Moran
Jay Musler
Nancy Hoffman Gallery
National Art Educators
 Association
National Art Materials Trade
 Association
National Association of Medical
 Illustrators

Maureen Russell Neil
New Jersey State Council on
 the Arts
Joe Nicastri
O. K. Harris Works of Art
Jerry Ott
Paasche Airbrush Co.
Particle Pal Bionic Systems, Ltd.
Jeanne Paschal
Pearl Art & Craft Supplies, Inc.
M. Pickel
Rodale Press, Inc.
Barbara Rogers
Paul Sarkisian
Susan Savage
Ben Schonzeit
Sheila Nussbaum Gallery
Social & Public Art Resource
 Center of Venice, California
Stacor Corporation
Peter Stallard
Arthur Steig
William Stenstrom
Strathmore Paper Company
Robert Sutton
Keung Szeto
Yeou-Jui Szeto
Noel Thompson
Lynn Turner
William Urban
Joel Jay Weissman
Peter West
William Westwood
Larry White
William Willhelmi
Winsor & Newton, Inc.
W. L. Wilcox, Inc.
Russell Woody
Howard Zoubek

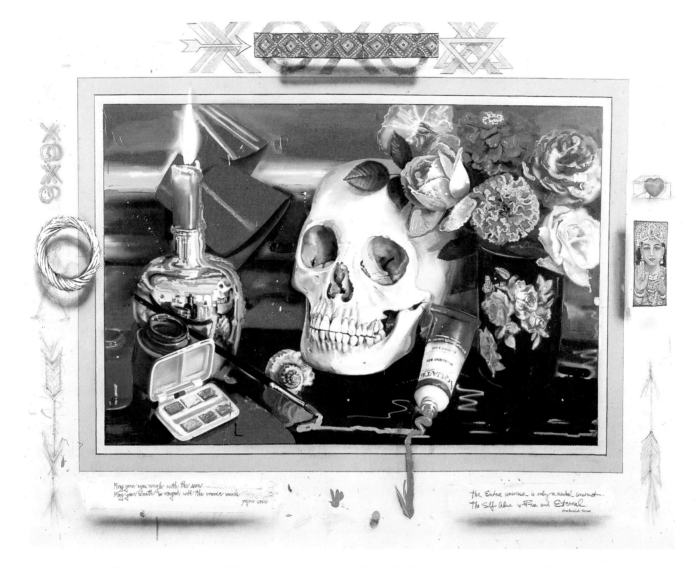

0-2. **Audrey Flack**, *Invocation*, 1982. Acrylic on canvas, 64″ x 80″. Photo: Louis K. Meisel Gallery.

Foreword

For years the airbrush was considered the province of the commercial artist, but the airbrush is only a tool and will obey its master. In the hands of a commercial artist, the product will become commercial art; in the hands of a painter, the work will become fine art.

In my current paintings I use brushes, crayons, markers, colored pencils, and several airbrushes. The actual act of painting with an airbrush has changed and expanded my ideas about color and light. Minuscule dots of pigment are projected out of the nozzle; they mingle with the air and land on the surface of the canvas. Any color will look totally different when sprayed with an airbrush than when it is applied with a brush. The more luminous, lighter, yet more intense color is the result of light bouncing (refracting) off dots of pigment rather than being absorbed or reflected by a brushed surface. The rapidity with which I can work is exciting. With swiftness and control I can glaze and shade and create smooth and sensual surfaces.

Many years ago when I first began to use the airbrush I was considered a heretic. I was treading on dangerous territory. There was little or no information available; the early painters using the airbrush stumbled blindly, finding their own ways. Through the years I developed many techniques and ways of dealing with masking canvas, diluting and storing paint, and straining it for use in the airbrush. All of this and more will be found in *The Art of the Dot*.

With Bob Paschal and Robert Anderson's expertise, *The Art of the Dot* is not only technical, but conceptual; it deals not only with the commercial aspects, but takes an overview that deals seriously with fine art involvement with the airbrush. Both Paschal and Anderson are painters themselves, and so the book is written by people who not only have technical knowledge, but understand by performance. This book contains a storehouse of information. I recommend it highly. ●

AUDREY FLACK

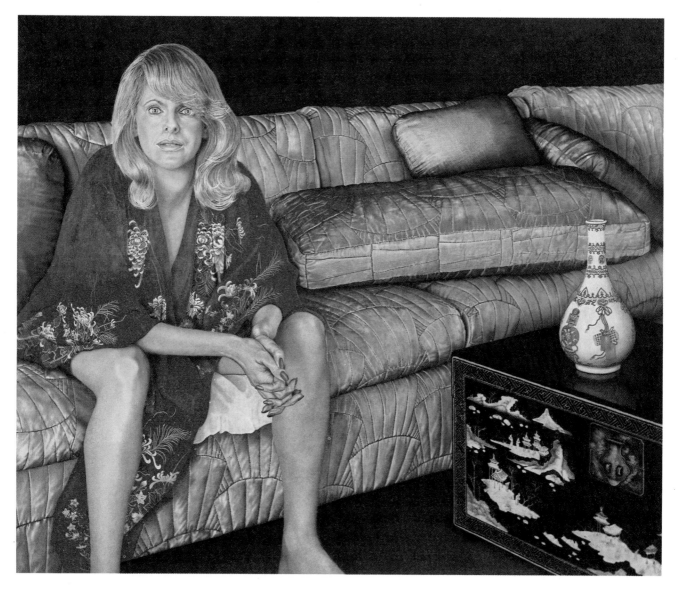

0-3. **Joe Nicastri**, *Toni*, 1983. Polymer fresco on board, 33½″ x 40″. Photo: Fred Boyle; courtesy Nancy Hoffman Gallery.

Introduction

The first thoughts that came to mind as we compiled this book on advanced airbrush technique were the processes the artist goes through to develop images with a particular tool on which a minimal amount of information is available. We set out to collect as much of this information as possible, both out of our own practical experiences and with whatever input we could obtain from other artists and craftsmen who are using the airbrush in some aspect of their work. In the course of gathering this information, our view of the intent of this book changed dramatically. Although we do deal extensively with compatible materials and applications, our purpose now is primarily to open up the field, to challenge preconceived notions of what is and what is not airbrush art, and to raise the question whether the term "airbrush art" should exist at all. In corresponding with a great number of artists who just happen to use an airbrush in their work, we found a great deal of resistance about being considered an "airbrush artist" as opposed to being considered simply an artist.

Historically, the airbrush has been assigned strictly to the province of the commercial artist, and although used in incidental ways in painting in the first half of the twentieth century, the airbrush did not come to be accepted on its own terms within the fine arts academic community until recent years. There has long been, however, much interest in the smooth, sensuous quality of a painted surface with no apparent brushstrokes. Artists such as Vermeer and Ingres worked their paint in such a way as to eliminate much of the brushstroke. Since the airbrush renders without brushstrokes, it can easily achieve this quality.

Some of the interest in airbrush technique that has been generated today is a direct result of the history of visual communication, starting with the development of the dot in reproduction. In the early days of offset lithography, the dot process used for developing the image was a direct influence on painters of the time. These postimpressionists developed their images by aligning dots of color adjacent to each other, thereby allowing the eye of the viewer to interpret the image. Photographic images and reproductions of those images, then and now, are actually made up of dots. Even today the image seen on television is, in reality, an array of dots. So, for years we have been both knowingly and unknowingly looking at dots but seeing images: when the dots are put together, they form an image.

Interest in an exacting image in painting was fostered by the appearance of countless reproductions of art in books and magazines. Some of these paintings were loosely rendered in their original state but appeared sharp when reproduced. As an example, think of the difference between a DeKooning painting in the original and a small reproduction of the same painting. In the original the paint is thick and loosely applied, but in the infinitely smaller scale of the reproduction, it appears flat with crisp edges. Several generations of artists have been introduced to art by viewing reproductions of original works. This indoctrination is one of the factors that has produced a desire by artists to produce a crisp image; this desire has developed a demand for and given credence to the tool that can produce this image: the airbrush.

There has always been animosity toward the airbrush by the academic community because of the airbrush's mechanical nature and because the airbrush artist does not actually touch the canvas or the work. Interest in the so-called hard-edge line from popular images, however, led artists to explore ways of developing these clean lines. Their methods included exacting brushwork, the use of masking tape and stencils, and spraying. The interest of pop artists in commercial images and the techniques used to develop those images helped legitimize the airbrush as a tool for use in fine art. Op artists were also interested in hard edges, but their primary focus was on the optical qualities of color. These artists would set up vibrations in their images by exactly juxtaposing coordinated hues, values, and edges. Precise hard edges and soft, gradated color and value changes are innate to sprayed paint, either freehand or in conjunction with stencils. The airbrush is simply a tool that sprays paint precisely. The interest in these effects helped to foster the airbrush's incorporation into the repertoire of the fine artist. Photo-realists, commercial illustrators, and photographers used sharp-focus realism in their efforts to achieve new effects, consequently tightening up pop art and extending pop images and rendering photographically things that may or may not exist. The logical tool to accomplish these feats

0-4. George Green, *Chasing Satan*, 1982. Acrylic on canvas, 90″ x 144″. Photo: Keith Jones; courtesy Louis K. Meisel Gallery.

was the airbrush. Throughout the history of airbrush use, the tool was primarily viewed as a tool to produce realistic images (as practiced by John Salt and Joe Nicastri). New styles such as abstract illusionism and mechanical pointillism evolved from interest in abstract impressionism and a rebellion against photo-realism. Interest in numerous other applications of airbrush technique has come with the recognition that the airbrush is not as limited in the imagery it can produce as was once thought.

This recognition has taken place simultaneously in both fine and commercial art. In product rendering and technical and medical illustration, however, airbrush technique is not changing as much as it is in fine art. For example abstract illusionist artists such as George Green and Michael Gallagher use the airbrush to develop illusionary space, whereas medical illustrators such as Bill Westwood and technical illustrators such as Al Grove still work in a classical airbrush manner because of the demands of their industry.

The airbrushed image does not have the startling impact it once had because of overexposure in galler-ies and reproductions. This, however, broadens, rather than limits, the appeal of the airbrush.

This is not a step-by-step, project-oriented book. Instead, *The Art of the Dot* is a pool of information and a collection of uses of airbrush technique by many artists. The "signature" of the work should not be the airbrush, and its style should not be identifiable as airbrushed. The airbrush can be an integral part of any work, regardless of whether it is used as the only tool or in conjunction with other artistic techniques, regardless of whether its use is obvious to the viewer or not. ●

0-5. Don Dixon, *Race in Space*, 1982. Acrylic and gouache on board, 16″ x 20″.

0-6. **Paul Bond**, technical illustration, 1983. Acrylic on board, 18″ x 24″. Courtesy Maremont Co.; Fred Dripps, art director; Creamer, Inc., agency.

0-7. **Michael Gallagher**, *Epipsychidio*, 1981. Acrylic on canvas, 44″ x 38¼″. Photo: Louis K. Meisel Gallery.

0-8. **Robert Anderson**, *Butterfly*, 1982. Acrylic on canvas, 50″ x 50″.
Courtesy Jack Gallery; collection Binney & Smith.

0-9. William Westwood, medical illustration for *The Physician and Sports Medicine*, 1982. Aqua media and color pencil, 14″ x 17″.

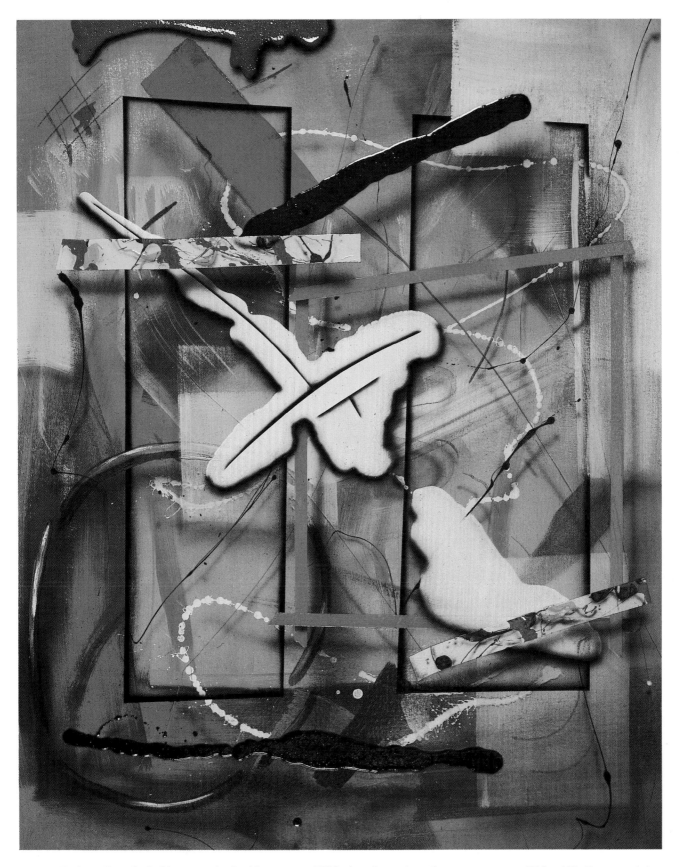

0-10. **Robert Paschal**, *Afternoon in the Hamptons*, 1983. Acrylic and urethane on canvas, 50″ x 40″. Courtesy Isis Gallery.

Part I Hardware

The airbrush itself and the equipment used in conjunction with airbrush technique are of course important; there may, however, be too much emphasis on the type of equipment used by the artist. The use and hookup of the airbrush and support equipment are fairly simple, at least in retrospect. The greatest problems in airbrush technique come not from the hardware, but from the software (paints, friskets, and surfaces) and the methods used to develop a visual image.

There has been an emphasis on the fineness of line achieved with an airbrush to qualify it as a professional tool, but in reality most fine-line work is done with a sable-haired brush or technical pen. Some of the most elaborate and involved airbrush paintings have been accomplished with the least sophisticated airbrushes (as seen in the work of such artists as Chuck Close and Don Eddy). This may indicate that it is not the airbrush's ability, but the artistic skill of the user that is most important. There are, nonetheless, some very important facts to know about the airbrush and compatible equipment. One must take into consideration desired visual effect, the working environment, and the financial outlay. This section will cover types and styles of airbrushes, air sources, accessories, and the maintenance involved in keeping the equipment operational. Also to be discussed are the layout of the studio, health hazards and prevention thereof, and some insight into running a business. ●

Airbrushes

The type of airbrush or spray gun used will influence the visual effects achieved. These effects are determined by the method by which the paint is sprayed—external mix, internal mix, or oscillating—and the pressure at which it is sprayed—high or low.

External-mix Airbrushes

The external-mix airbrush is the simplest in design of all types of airbrushes on the market today. Basically a miniature spray gun, it is used in the automotive field for custom van and motorcycle painting. It is also popular in the hobby and craft fields because of its ease of operation. Some commercial artists will keep an external-mix airbrush on hand strictly for stippling. This type of airbrush is also used in art to cover large areas of color; and in industry for small detail painting. It is to this relatively inexpensive airbrush that a great many artists are initially introduced.

The external-mix airbrush has two drawbacks that limit its usefulness for commercial and fine artists. It produces a coarse spray, and the volume of the paint flow is difficult to control. Because the air and paint mixture occurs outside the tip of the airbrush, the thoroughness of the mix (atomization) is decreased. The results are a coarse spray in which the dots are so large as to be visible as dots and a large amount of overspray (the drift of paint above and below the direction of spray). Moreover, to allow air to flow over the paint tip, all external-mix airbrushes require an adjustment for paint volume that is separate from the trigger action. Controlling thickness of line and soft gradations is consequently an awkward operation. To adjust the amount of paint that comes out of the airbrush, the user must either stop his hand movement and adjust the fluid tip of the airbrush or develop a two-handed method for simultaneous spraying and adjusting. The two-handed method works well

for artists working in a freehand style.

If the visible dot pattern is of no particular consequence in the finished artwork and if the awkwardness of adjusting volume can be overcome or overlooked, the external-mix airbrush is an excellent choice. It is inexpensive compared to other airbrushes and it is easy to use: Simply preset the amount of paint in the tip—clockwise for more paint, counterclockwise for less—and press down the trigger.

Depending upon the manufacturer, the fluid tip is held in place either with a set screw or nut for ease of removal to allow for cleaning or changing the tip. (Either an allen wrench or an open-end wrench supplied by the manufacturer is needed for removal. Be careful not to misplace these tools.) Most external-mix airbrushes can take fluid tips of various sizes— small, medium, or large—which will spray more or less paint of varying viscosity or particle size. All external-mix airbrushes are bottom-fed, thus making them both left- and right-handed. The paint is fed into the fluid tip either from a jar or a color cup. The external-mix airbrush can be worked at high air pressure (over 50 pounds per square inch) to accommodate high-viscosity media such as ceramic glaze or automotive paint.

With any airbrush, clean only those areas through which the paint flows. In the case of the external-mix airbrush, that means the fluid tip only. The cleaning can be done by spraying a solvent through the airbrush or by removing the fluid tip and soaking it in solvent. If paint is left to dry in the airbrush, it can be removed through soaking, or the tip can be opened with a thin needle. Of course, the color cup or jar siphon should be cleaned as well.

Internal-mix Airbrushes

In contrast to external-mix airbrushes, internal-mix airbrushes

give an innately softer spray. The air and paint are mixed together in a confined area inside the paint tip, where the paint is thoroughly atomized; the resulting dots are barely visible. These types of airbrushes can be used for virtually any application; they are the type most often used in commercial art. Internal-mix airbrushes will take various-size head assemblies. They are available with two different triggering mechanisms—single action, as found in external-mix airbrushes, and dual action, as in oscillating airbrushes.

As with the external-mix airbrush, the single-action internal-mix is bottom-fed and adapts to either jars or color cups. And the trigger works the same way—press down for air. The adjustment for the volume of paint, however, differs. In the internal-mix single-action airbrush, a needle-adjusting screw located at the back of the handle of the airbrush is turned counterclockwise for more paint and clockwise for less. (When turned counterclockwise the screw draws the needle away from the paint tip, allowing more paint to flow through.)

Clean this type of airbrush by flushing it out in the same manner as the external-mix, putting solvent through only those areas in which the paint flows. Then remove the needle for cleaning by unscrewing the needle chuck screw completely from the handle of the airbrush and drawing out the needle with chuck screw attached. (Leave the chuck screw attached to the needle because it comes preset from the manufacturer.) When replacing the needle, reverse the process, taking care not to bend the needle inadvertently. Single-action internal-mix airbrushes are as simple to use as external-mix airbrushes, but the type of spray achieved is better suited to fine and commercial art applications.

The dual-action internal-mix airbrush, the type most commonly used by professionals, differs in its

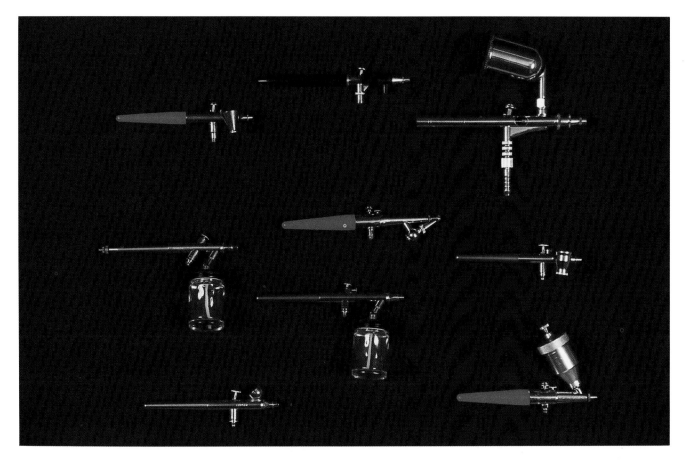

1-1. Airbrushes: Paasche Model H, Paasche Model V, Paasche Air Eraser, DeVilbiss Sprite Major, Iwata Model HP-E1, Badger Model 100XF, Badger Model 150, Badger Model 100GXF, and Badger Model 200.

triggering mechanism and style from the single-action airbrush. The dual action involves pressing down for air and pulling back for paint, allowing the artist to change the width of the line, the modulation of values, and the amount of paint being sprayed without stopping the hand movement. The width of line is determined by the distance between airbrush and work and the amount of paint being sprayed. Dual-action triggers are spring-loaded so they automatically return to a shutoff position when released. Most dual-action airbrushes are equipped with a trigger preset, which will allow the artist to set the amount of paint to be sprayed in advance for consistent application. Depending on the manufacturer, dual-action internal-mix airbrushes may have interchangeable head assemblies.

Dual-action internal-mix airbrushes are available with gravity-, side-, and bottom-feed mecha-

nisms. Preference for one style over another depends on application. The gravity-feed style has color cups permanently attached to the top of the airbrush. The cups vary in size from manufacturer to manufacturer and are the most difficult style to clean. Further, the larger the color cup, the more it blocks the view of the working surface and the more cumbersome the airbrush. Because gravity-feed airbrushes have small paint reservoirs and spray very fine lines, they are generally used where small amounts of paint are required or when a great deal of fine detail work is involved.

The side-feed style is the standard illustrator's airbrush. It is the only internal-mix airbrush that is not interchangeable for left- and right-handed use, but airbrushes adapted for the left hand may be purchased from the manufacturer. The color cups, available in various sizes, plug into the side of the airbrush. They

can swivel to allow the artist to work at any angle without spilling paint. Most color cups for side-feed airbrushes have a removable bottom to facilitate cleaning.

The bottom-feed style, as with the single-action internal-mix airbrush, can take jars or color cups of various sizes, thus allowing the artist to work with either small or large amounts of paint. The position of the jar at the bottom of the airbrush may, however, prevent the artist from getting close to the artwork. Also, because of the angle at which the jars are situated, it is difficult to paint straight down without dripping unwanted paint on the work. The color cups will also spill when spraying straight down.

When removing the needle for cleaning or replacement, the handle must be removed first; then the needle chuck screw is loosened; and finally the needle is withdrawn. Some manufacturers recommend

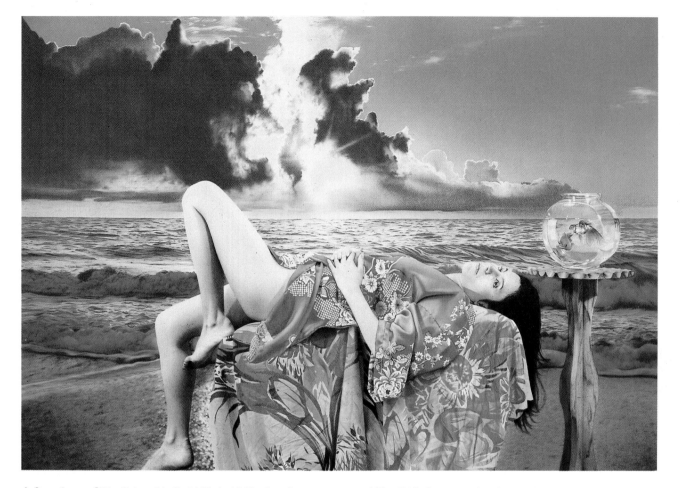

1-2. Jerry Ott, *Jilda with Gold Fish*, 1982. Acrylic on canvas, 49″ x 72″. Courtesy Louis K. Meisel Gallery

holding the trigger in place both when removing the needle and replacing it. Otherwise, the trigger may inadvertently fall out of the airbrush when the needle is removed and the spring-loaded trigger-return mechanism may become dislodged from position. (The needle runs through the center of the trigger, holding the trigger in place.)

Although the correct spray for a properly operating internal-mix airbrush is soft, the artist can achieve a coarse spray for stippling simply by cutting down the air regulator to one or two pounds pressure.

Internal-mix airbrushes range in price from forty dollars to more than two hundred dollars. Price is determined by the materials used in making the airbrush, the manufacturer, and the manner of triggering. Single-action airbrushes are less expensive than dual-action airbrushes.

Because of the size of the tip, internal-mix airbrushes cannot handle high-viscosity media. These airbrushes are, however, used most in the arts, because of the fine, granular spray they produce. Dual-action triggering adds to the versatility of these airbrushes. Internal-mix airbrushes are normally operated at 25–30 psi.

Keeping single- and dual-action airbrushes clean is essential to their proper operation. Between color changes of water-soluble media, quickly clean the airbrush by back-flushing with water as follows: wash out the color cup, place your finger over the tip (or, in the case of Badger airbrushes, unscrew the tip a bit), pull back on the finger lever in the case of dual-action airbrushes, and push down. The release of air will back-flush through the brush. Refilling the paint cup with water, spraying, and repeating this opera-

tion should adequately clean the airbrush for the next color. Some color cups have a screw-off bottom, which makes them easier to clean.

Be aware that spraying into the air during the cleaning operation will begin to fill the studio air with water vapor and paint. A solution is to keep a damp sponge in a shallow dish and spray into that.

For final cleaning at the end of a spray session, cleaning agents are required since any paint left in an airbrush overnight or longer may be difficult or impossible to clean out. Commercial spray gun and equipment cleaner or any lacquer thinner is recommended for use with non-water-soluble media. Follow the precautions outlined under *Health Hazards*. For water-soluble media use an agent such as Badger Air-Opaque Cleaner or a window cleaner formulated with ammonia. Air-Opaque Cleaner comes in a

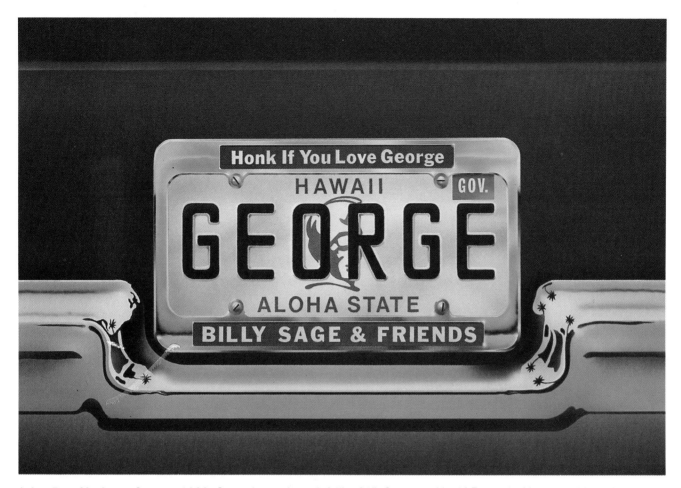

1-3. **Ron Hudson**, *George*, 1983. Gouache on board, 24″ x 24″. Courtesy Hashi Records, Honolulu, Hawaii.

plastic squeeze bottle, with which the solution can be injected into the airbrush.

There are several tools for cleaning the airbrush. The reamer is intended for scraping dry paint from inside the airbrush tip; however, it may, if used improperly, enlarge the paint tip or possibly unseat the paint tip entirely. Guitar strings make excellent "snakes" for cleaning color cups, jars, siphons, and other parts. These strings have flexibility and strength, and the larger ones provide an abrasive texture from their coiled construction. Pipe cleaners and cotton swabs complete the line of cleaning items. An apparatus that cleans airbrushes, airbrush parts, technical pens, and other studio instruments is the ultrasonic cleaner. Using a special solution, this cleaner knocks particles off with sound waves. Paint-covered parts come out of the cleaner completely

clean, the residue having been left at the bottom of the bath.

Oscillating Airbrush

The design of the oscillating airbrush is radically different from single- and double-action, internal- and external-mix airbrushes. (The Paasche AB is currently the only such airbrush on the market.) Although the triggering of the oscillating airbrush is similar to that of a double-action airbrush in that air and color are delivered by a down and back motion, it is otherwise a breed apart. The oscillating airbrush operates by driving an air turbine up to 25,000 rpm, which in turn moves a thin needle back and forth through a color cup. As the needle picks up small amounts of color, it passes in front of an air blast tube that blows off the paint. Because of its complexity, the oscillating airbrush is

one of the most difficult to master and maintain. Because of its complex tooling, the oscillating airbrush is one of the most expensive. This single-tipped, gravity-fed airbrush produces one of the finest lines achievable in airbrushing. It is, therefore, ideal for detail work but not for painting broad areas.

The oscillating airbrush has three adjustment screws that control the width of spray and the size of the dots being sprayed. The working pressure of the oscillating airbrush is from 14–45 psi. The starting spray width is adjusted by the lever-adjusting (preset) screw in back of the finger lever; as it is screwed in, more of the needle moves in front of the air-blast jet, producing a wider line. The speed-regulator screw, located toward the front of the airbrush, is a screw valve that, when turned clockwise, slowly closes off the air supply to the turbine. This in

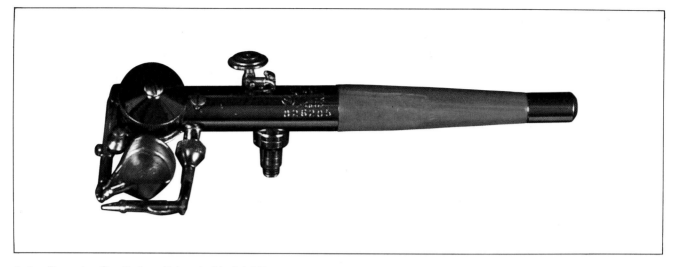

1-4 Paasche Oscillating Airbrush, Model AB.

turn slows the needle movement, decreasing the amount of paint delivered onto the needle and producing a finer line. Slowing the turbine too much will cause a series of dashes to be blown off the needle rather than a continuous line. Stippling is achieved by closing down the air supply to the air-blast tube by turning the screw located at the back of the tube clockwise. These three adjustments must be made before beginning work and should be tested on scrap paper. If the air-blast jet orifice gets clogged with paint, open it with a sharpened toothpick, not a metal reamer, which may enlarge the opening.

In addition, there are several other important adjustments that may have to be done on the oscillating airbrush before spraying. First, the color cup must be positioned. Do this by inserting the elbow of the needle first through the walking arm; then into the walking arm slot; along the needle guide; into the bearing; and finally adjusting the lever-adjusting screw until the needle elbow is just a hair away from the end of the slot. This prevents the needle elbow from contacting the end of the slot. Then loosen the color cup support screw; move the color cup in or out until the needle projects 1/32"–1/64" beyond the end of the needle bearing. Retighten the color cup support screw. The proper air-blast tube location can be determined by first loosening the air-blast tube locking nut and screwing the

tube in or out until the end of the air-blast jet is 3/64" from the needle bearing. After tightening the locking nut, make the last adjustment with the finger lever (trigger) pulled and the needle extended. The distance from the needle back to the air-blast jet should also be 3/64". If it is not, carefully bend the air-blast tube until it is or send it back to the factory. Finally, move the air-blast tube up or down to center its opening with the tip of the needle. Returning an airbrush to the factory for repair is good advice for any adjustment procedure you feel uncomfortable doing.

General Maintenance and Operating Tips

The following is a guide to special adjustments and maintenance procedures. All maintenance procedures should be done with no air pressure.

1. Needle Replacement—This is the most frequently performed and easiest of all maintenance procedures with the oscillating airbrush. Using tweezers, pull the old needle up between the needle guide and the bearing housing, and then remove it from the drive unit or walking arm. Straight needles come housed in the handle of the airbrush. Before inserting a new needle, bend it slightly with your fingers in two directions: when properly installed in the airbrush, the needle should bow up slightly, making contact with the needle guide, and bow

in slightly toward the airbrush so that it rides just under the needle guide. This bending procedure requires some practice but is not difficult. You may also want to sharpen a new needle before installing it to get a finer control of the paint flow. Do this by pulling the needle through a fine emery paper, thereby extending the taper.

2. Needle Bearing Replacement— This part will wear under normal use and should be replaced when the needle groove in the bearing becomes disfigured. Inspection with a magnifying glass will reveal this wear, caused by travel of the needle. To replace the bearing, remove the needle and place the flat side of a screwdriver blade against the back of the bearing, the part closest to the power wheel housing. Push hard on the bearing at this point and it will come out.

At times you may want to remove a needle bearing that is still good but needs a thorough cleaning. A reamer is a good tool with which to scrape dried paint off the bearing. Remember to clean the hole in the side of the bearing. Before replacing the bearing, clean its housing as well with a reamer.

To install a bearing, simply push it in tightly, making sure to align the hole in the bearing with the opening in the color cup and the slot on top with the path of the needle. Place a dab of petroleum jelly at the back of the bearing to provide lubrication for the needle.

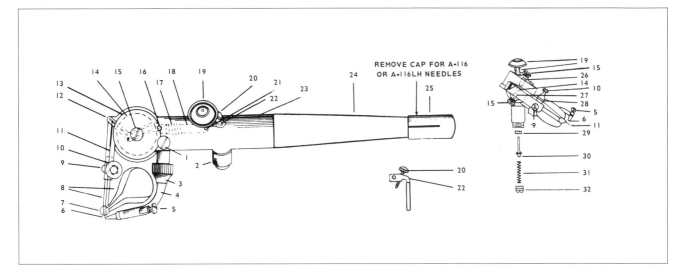

Paasche Oscillating Airbrush, Model AB. Exploded view and parts list.

The AB Airbrush is not suitable for use with alcohol or lacquer colors. Any watercolor, oil, or opaque can be used with brilliant results.

1 (A-140): speed regulator screw
2 (A-128): valve casing
3 (A-173): air-blast tube assembly (right-hand)
(A-173LH): air-blast tube assembly (left-hand)
(A-139): air-blast tube locknut
4 (A-138): air-blast tube (right-hand)
(A-138LH): air-blast tube (left-hand)
5 (A-146): stipple adjuster
6 (A-101): air-blast jet
7 (A-177): needle bearing (right-hand)
(A-177LH): needle bearing (left-hand)
8 (A-179): color-cup assembly (right-hand)
(A-179LH): color-cup assembly (left-hand)
9 (A-160): color-cup screw
10 (A-142): needle guide
11 (A-116): needles—dozen (right-hand)
(A-116LH): needles—dozen (left-hand)
12 (A-107): walking arm
13 (A-131): wheel housing (right-hand)*
(A-131LH): wheel housing (left-hand)*
14 (A-172): powerwheel and shaft assembly*
15 (A-114): grease cup—screw
16 (A-106): walking-arm shaft—screw
17 (A-105): walking-arm spring
18 (A-104): walking-arm plunger
19 (A-121): finger-lever assembly
20 (A-60): lever adjusting screw

21 (A-58): lever pilot
22 (A-14): lever fork
23 (A-122): shell (right-hand)
(A-122LH): shell (left-hand)
24 (A-61): handle
25 (VL-118): protecting cap
26 (A-133): top shaft bearing
27 (A-154): bottom shaft bearing
28 (A-143): needle-guide spring
29 (A-52): valve washer—dozen
30 (H-21A): valve plunger*
31 (A-22): valve spring
32 (A-23A): air-valve nut

Accessories (not shown)
(A-34): airbrush hanger
(A-64): screwdriver
(A-117): tweezers
(AB-CASE): case (free with airbrush)
(A-1/8"-6'): airhose with couplings
(A-1/8"-6'MT): airhose with moisture trap
(AC-1/8"-1/4"): coupling
(MT): moisture trap
(HF-1/4"): valve assembly

Number in parentheses is Paasche part number.
Asterisk indicates part must be fitted at the factory.

3. Lubrication—Unlike other types of airbrushes, several moving parts on the oscillating airbrush require periodic lubrication. A drop of light household oil should be used on the pivot of the finger lever, on the walking arm where the needle inserts, and on the needle in the needle guide area. The top and bottom shaft bearings also require lubrication. This is accomplished by making sure that the grease cups located on the top and bottom of the power wheel assembly are full of petroleum jelly or watchmaker's grease. The cups easily screw out for filling, but be careful not to cross-thread or damage the internal threads when replacing these screws. ●

Other Spray Equipment

Air-operated tools other than airbrushes are also used in the creation of artwork. These tools include various types and sizes of spray guns and miniature sandblasters called air erasers.

Spray Guns

Spray guns are large spray units used to cover broad areas quickly. In contrast to airbrushes, they will spray thicker paint as well as materials of greater particle size but require greater air pressure and volume to do so. The larger the spray gun, the more overspray occurs in the studio environment. A great deal of care, therefore, should be taken when using these types of equipment in confined or unventilated areas. Spray guns vary in size. One of the most widely used in the art field is the intermediate-size or detail touch-up gun. It is slightly larger than an airbrush, but smaller than a production spray gun, and is triggered from the top. It will produce a broader spray than an airbrush, 1/4"–5" wide. The spray pattern can be adjusted to be either horizontal or vertical and will produce either a round or flat spray. Most spray guns are available with tips of various sizes. Among the ideal applications for the intermediate-size gun are spraying varnishes, automotive paints, and ceramic glazes. Another type of spray gun is a Metalflake gun, designed to spray Metalflake paints. The Metalflake gun has a propellor inside the paint pot, spun by air, which keeps the heavy metal flakes in the paint suspended for even application. This suspension can also be accomplished with two or three 1/2" ball bearings in the paint cup of a regular production spray gun; however, the guns must be shaken periodically while spraying. Spray guns are ideally suited for work on large flat areas because they cover quickly and have large paint pots. They can be connected to an external pressurized paint supply (from 1 to 5 gallons) to cover even larger areas. This equipment is useful for painting murals and stage sets.

Air Erasers

An air eraser is a miniature sandblaster somewhat similar in design to a gravity-fed airbrush. An abrasive powder is sprayed through this tool to etch glass and plastic and to prepare surfaces for painting. The air eraser can also be used to remove paint, ceramic glazes, and other media from dried, finished surfaces for a variety of effects. (See *Ceramics*, in Part III.) It is used as well for cleaning jewelry and sculpture castings. ●

1-5. **Alan Hewson**, *Tropical Sunset*, 1982. Acrylic and enamel on venetian blinds, 4' x 4'.

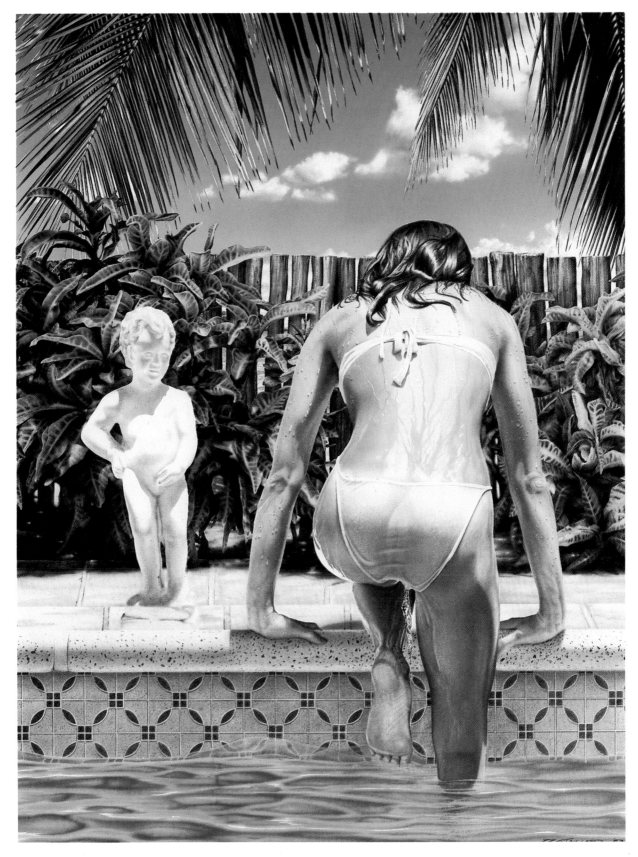

1-6. **Peter Stallard**, *Lady Leaving the Pool*, 1983. Gouache and dyes on illustration board, 30″ x 20″.

Air Sources

There are numerous possibilities available as sources of air for airbrushes and related equipment. In making the selection of air source, an artist must consider several factors. First and foremost is the size and number of spray equipment or tools to be propelled by the air source. The normal consumption of air by an airbrush is 0.5 cubic foot of air per minute (cfm) at 25 pounds per square inch (psi). Spray guns, on the other hand, consume quite a bit more air at various psi's (starting at about 1.7 cfm with the smallest of spray guns). The second consideration is financial outlay: the larger and more sophisticated the air source, the more costly. A final consideration is the amount of noise the air source produces. In general, the quieter, the better; but that also means the more costly.

Diaphragm Compressors

The most common air source in airbrushing is the compressor. There are two basic types—diaphragm and piston—of which the diaphragm compressor is the less expensive. Diaphragm compressors designed for airbrush technique can propel one airbrush. Although larger diaphragm compressors are available, they are usually not used because they are expensive and noisy. Moreover, because of their low cfm, most diaphragm compressors can handle only airbrushes, not larger spray equipment. Avoid pulsating diaphragm compressors, which will produce a visible pulsation in the spray of the airbrush. Most diaphragm compressors run continuously if they are plugged in, regardless of whether the airbrush is actually in use. If so, they should be self-bleeding to allow air to escape from the compressor when the airbrush is not in use. A continuously running compressor should be shut off periodically (at least once an hour) to allow it to cool down. An inline moisture trap is essential to deal with moisture buildup in the air line. Some diaphragm compressors, such as the Badger 180-11, come equipped with automatic shutoff switches that are air-operated. These compressors run only on demand, thus preventing overheating and the nuisance of excess noise. Foot switches are also available for diaphragm compressors to turn them on and off. Most diaphragm compressors are maintenance-free.

Piston Compressors

Piston compressors are available in a variety of sizes and are ideal for studio situations in which more than one airbrush will be used at any given time or for propelling tools requiring more air than an airbrush does. This is because they produce a much higher volume of air than do diaphragm compressors.

Piston compressors are usually situated on top of storage tanks. Because the air produced is pressurized in the storage tank, there is no pulsation in the spray. Since the compressor is filling the storage tank, an automatic shutoff switch is built into the compressor that is activated at a certain psi, normally 100 pounds. This prevents the tank from becoming overpressured. If for some reason the tank is overpressurized, these compressors are equipped with a safety release valve. As the air is depleted from the storage tank and reaches a pressure preset for the compressor, it will start up automatically. Because of the high pressure in the tank, a regulator is required for airbrush work.

Piston compressors are available as self-lubricating units or as units in which oil must be added to the crankcase. With the latter there is always the possibility that oil may reach the air line. A trap should, therefore, be placed at the regulator to collect undesirable residues.

Piston compressors are more expensive than diaphragm compressors because they are noisier and cost more to manufacture.

Newly introduced to the American market is the silent piston-operated compressor. It has an oil-floated refrigeration motor that makes virtually no noise while operating. It produces a lower cfm per unit of horsepower than a standard diaphragm-

1-7. Fat City Café, San Diego, California. Airbrush design for a menu cover.

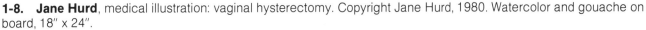

1-8. Jane Hurd, medical illustration: vaginal hysterectomy. Copyright Jane Hurd, 1980. Watercolor and gouache on board, 18″ x 24″.

or piston-operated compressor. Depending on size, silent compressors can propel from one to four airbrushes simultaneously. The oil must be maintained to proper level and checked periodically. The holding tank must be emptied daily to prevent oil buildup, and a trap should be used at the regulator. Compared to other compressors, this type is the most expensive but is the best solution when using compressors in work spaces where noise is a factor.

Compressed Gas

Compressed gas tanks can be either rented or purchased and are available in different capacities. They are nonelectric, portable (using wheeled holding racks), silent, and the cleanest source of air (no moisture or oil). They do require purchase of an expensive regulator, which indicates both tank and line pressure, as it does not come with the tank rental. Tanks must be refilled periodically, so a spare tank is recommended. It is impractical to run more than four airbrushes off a compressed gas tank because of the quick depletion of the compressed gas.

The gas used is carbon dioxide or nitrogen. Nitrogen is preferred since it does not retain moisture and will prevent water from entering the airbrush as well as freezing up the regulator. When CO_2 tanks are overfilled, they freeze the regulator, causing it to malfunction and build up excess line pressure. Make sure these tanks are secured to a holding rack or the studio wall, as they may tip over and cause damage.

Propellant Cans

These small canisters of propellant are designed for hobby applications, starter kits, and as a backup to general studio use. Propellant cans are available in small and large cans and cost four to six dollars. A propellant can will propel one airbrush at a time. Small cans will give about twenty minutes of consistent spray; large cans will give about forty minutes of consistent spray. They require a regulator to adapt the can to the airbrush hose. Propellant cans get very cold when used, which reduces the pressure greatly. They must be brought back to room temperature periodically for full pressure. Keeping the can in a container of warm water helps maintain an even temperature. They are not recommended for prolonged professional application. ●

Studio Design

The studio plan and environment depends on the type of work being done. A photo retoucher's studio will be much different than that of a ceramicist. Within each medium, except for painting, the studio environment is very similar because of certain physical requirements. Because painters do not, in general, have large equipment such as kilns, welding apparatus, or etching presses, they have more freedom to design their studios as they like. Once the airbrush is introduced to the studio, however, certain limitations arise. This is because the airbrush is attached to an air source, is a mechanical instrument, requires maintenance, produces overspray, and relies on other mechanical systems such as frisketing, taping, and cleaning. Added to these characteristics are the intrinsic hazards of atomized paint application. The inhalation of paint particles, solvents, and toxic pigments should be of especial concern to artists who use airbrush. The artist is exposed to many health hazards through the art materials he uses, and spraying compounds these problems.

For the artist building a studio, the application and scale of the work will determine the studio's dimensions. In most cases, however, an existing space will be adapted for studio use, and its size will determine the maximum size of the work. The location of the airbrush and related equipment will then be determined by the logistics of the work area. The following suggestions for airbrush equipment apply no matter what the application.

Location of Air Source in the Studio

The location of the air source will vary depending on the particular type of air source, application, and studio layout. If noise is not a factor, the closer to the work area, the better. Because there is a 5 psi loss for every 50 feet of air line, keeping the tank close by will avoid pressure loss caused by extra tubing; further-

more, adjustments in line pressure are convenient to make. A portable tank caddy makes it easy to place the tank in storage and wheel it to the work station when needed.

If the compressor is noisy, it should be somewhat isolated to cut down on the noise level in the studio. This can mean placing the unit in a closet, attic, basement, or adjoining room and running the air to the work station. Rubber air hose, PVC, copper, or black pipe can be used for this. Isolating the compressor by building a soundproof box to fit over the unit allows it to be close to the work area and yet somewhat quiet. Either of these solutions will also help to keep paint and other dust from clogging the air-intake filter.

Air Regulators, Moisture Traps, Connectors, and Hoses

A combination regulator and moisture trap should be installed in the air line to allow periodic adjustments in line pressure that become necessary while working and help to keep the air free of moisture and oil.

If more than one airbrush is used in the work, each can be tapped into a multiple outlet system. This can be arranged with either individual shutoff valves or with all the lines "live." (Air surge is a possibility with more than one user but can be prevented by having an air regulator at each airbrush hookup.) In a multiple outlet system, more than two lines tend to get fouled unless they are on a spring to retract the slack. In a classroom or production studio situation, multiple lines can be run off an air main that runs along the wall or ceiling, with outlets at each station equipped with a regulator and quick disconnects. These connectors come in two parts with the female terminal attached to the air line and a male terminal attached to each airbrush hose. Quick disconnects allow quick airbrush changes and are available from automotive paint and parts supply stores. The

above installations may require various fittings, pipe T's, and reduction adapters, all of which are available at plumbing supply houses. Each pipe thread should first be tightly wrapped with Teflon tape to avoid air leaks.

Airbrush hoses are available in vinyl and in rubber with a braided cover. Coiled hoses are available to allow a long reach without the line getting tangled or being underfoot. Swivels at each end connector are desirable to eliminate kinking. Be sure that the hose length is adequate to reach all areas of the work. An in-line moisture trap is a good idea even if there is one on the compressor as these small units will eliminate any moisture that the first trap misses.

Airbrush Holders

Airbrush holders are usually packaged with a new airbrush and are meant to be attached to a wall, wooden easel, or taboret. Made of soft metal, they are pliable enough to be formed to fit almost any airbrush. Other holders commercially available include a drop-lock holder that fastens to a secure object in the working area by means of a vise clamp and a foam-type holder that, by means of a press fit with dense foam, holds the airbrush by its handle. Super Klip, a general-purpose item available in hardware stores, can be mounted with its self-stick backing; the airbrush is secured by simply being pushed into the center. Other holders can be improvised. For example, a large screw eye is suitable for running the air line through and resting the airbrush on. Coat hanger wire can be bent to suit this purpose as well. A drill bit holder with its different-size holes makes a good storage unit for airbrushes as well as razor knives, technical pens, and drawing pencils. Some taborets and carousel trays also have holes and devices that can be used to hold—or adapted for holding—airbrushes.

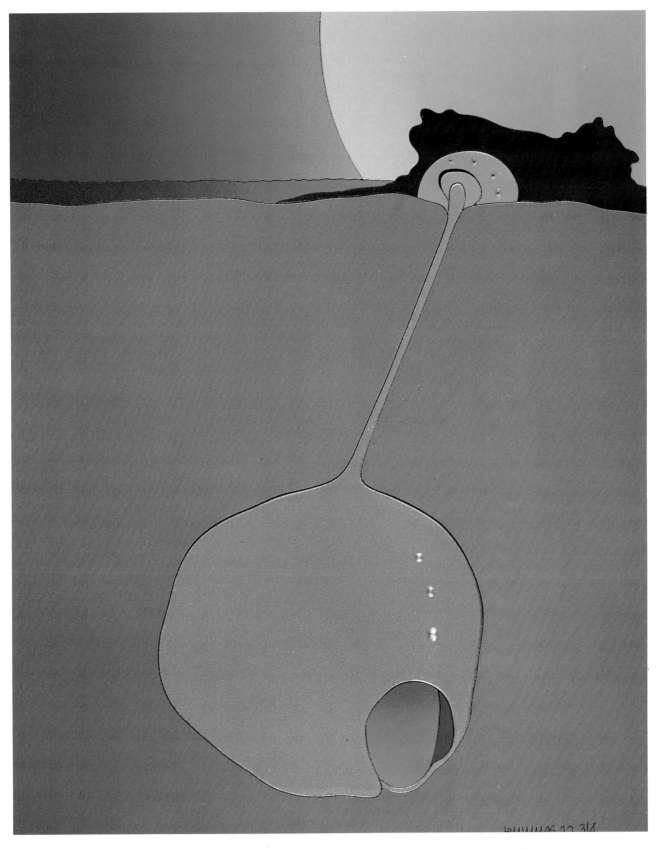

1-9. **Rixford Jennings**, wooden jigsaw puzzle, 1978. Lacquer on wood, 8″ x 10″.

Studio Furnishings

The furniture that may be required in a studio will vary with the type of art produced and the materials used. Obviously a stone sculptor will have little use for many of the fixtures required by an illustrator, so only a general list of items will be presented here.

Taborets or *cabinets* not only store airbrush supplies, but may second as paint-mixing and work stations. They can hold portable sinks and provide a mount for airbrush holders. Made of wood or plastic, they are sometimes fitted with wheels for easy movement.

Chairs or *stools* are a necessity if a lot of work is done at a drawing table or wall easel. The state of the art in studio chairs is well designed with firm foam support on the seat, smooth adjustment to raise and lower the stool as well as for lumbar support. Available with or without wheels, they can be an expensive item but worth the investment if much of the workday is spent sitting.

Easels are commercially available in wood or metal, adjustable for both height and angle (both forward and away from vertical). Generally, metal easels are a bit sturdier and not subject to warping or the wear of adjustable parts. Some metal easels are designed to rotate the work for quick access to all areas. The James Howard easel is made of stainless steel, has a provision for a stand-off palette tray, and grips the art at top and bottom without overlapping it. Wall easels permanently attach to a wall with only an up-and-down adjustment. They can be elaborate, with tongue-and-groove sliding grips for the work, or as simple as two vertical rows of nails placed at least as far apart as the width of the stretcher bars. A more convenient variation on this design is two vertical wooden planks with holes drilled ½″–1″ apart, into which small pieces of wooden dowel are inserted to support the painting.

A *drawing table* is necessary for most artists. It consists of a base and drawing surface that has an adjustable angle and can be raised or lowered. The drawing board surface may be hardboard or laminated (with a material such as Formica). The hardboard is generally made of several pieces of wood glued together, which may begin to separate in time, creating an uneven surface. To remedy this either reglue and sand, reinforcing the back with metal support bars, or cover the surface with a hot-press illustration board. This will help smooth any bumps or variations in the surface. Vinyl and linoleum sheets make excellent drawing table surfaces, since they are somewhat flexible as well as durable. A sheet-metal surface not only provides a smooth drawing surface, but can be used with magnets to hold down acetate stencils. (See *Masking Materials— Acetate*, in Part II.)

A *drafting table* has all the features of a drawing table with the addition of those mechanisms necessary for producing various angles and straight edges. This type of setup would be used in fields such as graphic design, mechanical drawing, and architecture.

Worktables provide an all-around flat work area for cutting mats, laying out designs, wrapping work, and other activities. The table should be waist high and can be made cheaply from a used hollow-core door and sawhorses or a leg kit. In a small studio space, one end of the table can be hinged to the wall with the support legs hinged to the bottom of the table; the table can be stored flat against the wall when not in use.

Storage shelves are a must, for there never seems to be enough storage space in a studio. Along with taborets, cabinets, and closets, shelves offer a lot of storage capacity for very little sacrifice in space. Shelves may be located out of the way under the worktable, as a free-standing unit, or on adjustable wall-mounted brackets. An easy and inexpensive unit can be constructed of 1″-X-12″ particle board using 12″-X-12″ cement decorator blocks to support each level.

A *flat file* also provides needed storage for the assorted drawings, prints, and paper that must be kept flat and protected from paint overspray. They also provide a file for often-used acetate or paper stencils. (See *Filing Systems*.) These files are available in wood or metal, can be stacked, and provide excellent dust-free storage. If fully enclosed storage space is not possible, make sure to wrap with plastic any artwork open to the studio environment.

A *light table* or *light box* is an important studio appliance for artists involved in paste-up, mechanicals, retouching transparencies, and checking on image sharpness or color balance. Much of the preparation for four-color offset requires a light table as well as a magnifier or loupe. Light tables or boxes allow quick tracing of important elements in a design (even through fairly opaque paper) to aid in the composition of line, form, and color.

A *sink* is an essential fixture for all artists. Water is necessary in the cleanup of airbrushes, bristle brushes, jars, and other equipment; it is also the thinner for most airbrush media. Nonetheless, locating a sink near the work station is in most studios either physically impossible or financially impractical. The airbrush artist, however, dealing with many color changes throughout the day, needs water. The Badger Air-Brush Company makes a portable sink that remedies the problem. This small sink holds and recirculates water and other cleaning agents without plumbing. It is an electrically operated unit that may be operated by hand or foot switch. In a ceramics studio or any other studio in which the sink drain may clog from semisolid waste, a drain screen or heavy-duty trap may be required.

Temperature and humidity con-

trols are needed in any workplace where many hours are spent and comfort is thus of prime importance. If finances permit and climate dictates, summer air-conditioning makes a big difference. Studio temperature and humidity should be controlled year-round for the benefit of stored work as well as for the artist. Plastic-wrapped acrylic painting, for example, may become moldy if kept in a dark closet or storage vault with high humidity. If summer air-conditioning is out of the question, at least run a dehumidifier at all times and a small fan when the studio is in use. This will ensure more even temperature distribution as well as help keep the air clean. (See also *Health Hazards—Studio Ventilation.*)

A *radio* might be considered by some a necessary element of studio furnishings. As most art production requires long periods of intense solo activity, some interaction with the world outside might be desirable. For some artists this might mean Bach, rock, or "all-talk" radio; for others, a variety of background noises to keep them company is all it takes. Some artists are most comfortable with what is known as white noise, a constant tone or sound, devoid of any musical elements, generated by a special machine. Other artists cannot tolerate any intrusion, either audible or visible, into the work at hand. Whatever the choice of "studio companion," it almost never includes television. Extraneous visual elements do not seem to be compatible with those of concern to the artist.

Color Mixing Area—Since mixing colors is high on the list of importance in terms of the finished piece of art, the organization of an area in which to do it deserves some thought. It could consist of no more than a small taboret located in the airbrush work area or can be as elaborate as a paint manufacturer's laboratory. However large or small the area might be, it should be covered with a plastic tablecloth or vinyl

cover. This makes cleanup easier, and the cover can be periodically replaced at little cost.

An important consideration in the design of the paint mixing area is storage. The paint should be arranged so that all colors are visible and accessible. Jars of already mixed colors should be cleanly labeled and arranged so that colors need not be searched for. Arrange jar or tube colors in a small series of steps, one line for cool colors and one line for warm, with added space for whites, blacks and mediums.

The colors can be mixed in disposable plastic drinking cups. These come in a variety of sizes and colors, the white ones providing an excellent background to mix against. Do not use paper cups, as they disintegrate easily. Gouache and watercolor may be left to dry in the cups and reconstituted with water when needed. Acrylic, on the other hand, must be kept liquid in a covered container if a particular mixture is to be used again. Baby food jars serve the purpose well if you can find a donor. For smaller amounts, try black plastic film canisters, which my be obtained free from a photo shop. Label with a bit of masking tape on which a dab of color is applied. A variety of colors can be stored in airbrush bottles, using pipe cleaners as stoppers, and connected to the airbrush as needed during production.

As acrylic is susceptible to mold, especially in dark closed containers, mix a drop of Lysol into the paint. Once established, the mold spores in the paint are readily transferred to the painting ground by brush or airbrush, where they will remain until conditions are right for growth.

For mixing smaller quantities of color, plastic and ceramic palettes or trays designed for the photo retoucher and airbrusher are well suited to watercolor and gouache. Dried acrylic tends to stick to these, making them difficult to clean even when soaked, so acceptable alternatives are a disposable sheet

palette, a thick glass palette painted with white enamel on the back, a white Teflon cookie sheet, film canisters, airbrush jars, or tablet cups (available from a hospital supply house).

The colors should be mixed thoroughly with a small bristle brush and then loaded into the airbrush directly from the brush or with an eyedropper. If coarse pigments or bits of dried paint clog the airbrush, filter the colors before loading the airbrush. This can be done cheaply with a piece of nylon stocking, although funnel filters are available from commercial paint supply stores with several sizes of mesh openings.

To aid in quick color changes and mixtures, the Binks Airbrush Company has developed what it calls the Chameleon system. Consisting of a pressure-feed pot with nine color wells, it allows the artist to switch quickly from one color to another and to mix colors automatically. The system is limited in that it works only with the Binks airbrush for which it was designed, will mix colors in adjacent wells only, and is able to mix only two colors at a time.

Color mixing can be made more predictable with the help of charts such as the Liquitex color map. Such charts give the artist the ability to mix within value levels, to mix color and retain intensity, and most important, to arrive at the desired hue without experimentation and the frustration of getting "mud." The Liquitex chart also shows colors as they appear in tint and glaze form.

Studio Lighting

Studio lighting may be natural or artificial. Natural sunlight is preferred by many artists because it is from this light that our eyes learn the color spectrum. Getting natural light into a studio, however, requires unobstructed windows or, if practicable, skylights. Even so, natural light is not a dependable source: on cloudy days the intensity wanes,

and at the beginning and end of the day, the color of the light shifts toward red.

Artificial studio lighting, on the other hand, is available both during the day and night and in all weathers, and it is color constant, though not necessarily color balanced. Whether fluorescent or incandescent, artificial lighting favors some colors over others; fluorescent light tends to enhance cool colors, whereas incandescent lights favor warm colors. This color shift will be evident when viewing in natural light work done under an artificial light source.

It is possible to achieve color-balanced artificial studio lighting. Some fluorescent tubes are designed to produce balanced light. These are sold under the name GE #50 made by General Electric. Or a combination of fluorescent and in-

candescent sources—two 40-watt fluorescent tubes and two 40- to 50-watt tungsten spots aimed at the work area—will produce a fairly balanced mixture. Fixtures are available to accommodate such a setup using a fluorescent ring with a spotlight in the middle.

Some gallery artists believe that the work ought to be produced under the same lighting conditions in which it will be seen. This means using tungsten spots or floods, which produce a warm light. This can be achieved with fixtures that clamp on to studio furniture or the easel.

When setting up your own color-balanced system, be sensitive not only to how it affects the work you do, but also to its effect on your mood. Totally balanced light may be a little too "cool" psychologically to work in for long periods of time.

Accessories

Any number of accessories are available to aid the artist using airbrush. Many are necessary, others make the particular technique much easier; some are designed specifically for the airbrush, others are not but may be applied by artists in unconventional ways.

Razor Knives—Cutting friskets requires a razor knife handle and very sharp blades. The knife handle can be of the type that holds the blade in one position only, has a swivel grip, or is a combination that swivels and locks as needed. Of the swivel type, the ball-bearing design is best, as it is most responsive to movements of the hand. In the stationary type, such as the X-Acto, use stainless steel blades where possible as they last longer than carbon steel blades and are worth the extra expense. The number 21 blade, for example, is the stainless steel equivalent of number 11. Other specialized cutters are available, such as compass razors and double-cut knives.

Sharpening Stones—Replacing blades can get expensive, as most frisket and stencil material dulls blades quickly. Buying in quantity and replacing blades when dull is normally suggested, but sharpening the blades is a viable alternative. With a sharpening or honing stone, some oil, and a little practice, you can give used blades a quick new edge. Draw the blade toward you at the proper angle two or three times for each side.

T-Squares and Straightedges—These are used for drawing, cutting, or spraying straight lines. They should be made of metal for mat cutting, with a nonslip cork or rubber bottom. Airbrushing over a straightedge lying flat on the surface will produce a hard-edged line. As the straightedge is lifted off the surface and the spray is directed at an angle across the straightedge, the line softens. A straightedge can also be used as a guide to direct the hand

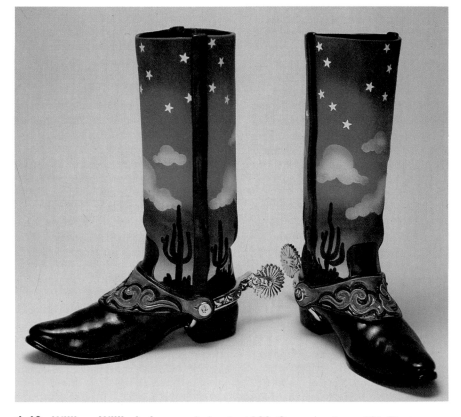

1-10. William Willhelmi, ceramic boots, 1983. Ceramic glaze, 16″. Photo: Ronald Randolf.

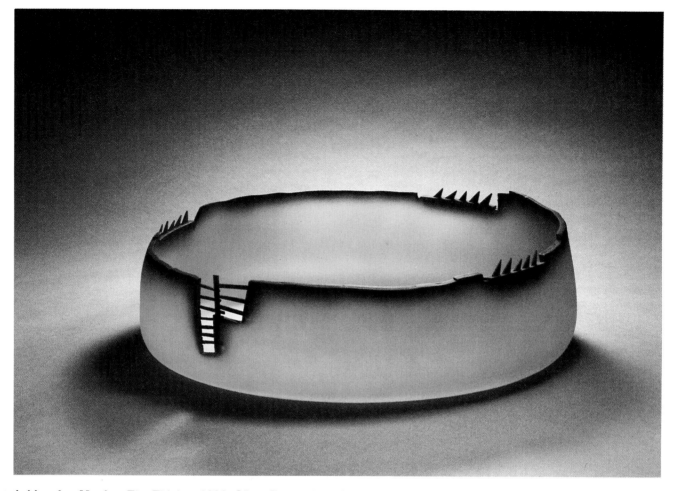

1-11. Jay Musler, *The Thinker*, 1983. Oil on Pyrex glass, 20″ x 6½″. Courtesy Heller Gallery.

as it holds the airbrush.

Miscellaneous Drafting Tools— Curve guides, angles, and templates assist in various types of drawing as well as providing shapes to spray over and around. Templates intended especially for airbrush are available, to be hand-held and to mask areas without having to frisket. These can be purchased or made with thick acetate or cut from Plexiglas in shapes that may be used repeatedly for different projects.

Tapes—Drafting and masking tape are useful for masking off areas before spraying. These tapes are available in widths from 1/2″ to 3″. If lines narrower than this need to be masked, graphic arts tapes are available down to 1/32″. A variety of tape dispensers are available to keep the tape accessible and allow one-handed use. Some are weighted and others screw or clamp on while offering three- or four-roll ca-

pacity. Adhesive transfer tape dispensers roll out a strip of strong, clear adhesive ideal for mounting and framing purposes. A masking machine used by the auto body trade can be of use in the studio as it dispenses brown masking paper edged with a strip of tape.

Graphic arts tapes, normally associated with photographic and printing use, may be of value in airbrushing. Scotch 285 Artist's Tape, for example, can be used when a very crisp, straight line is desired since drafting tape sometimes produces a fuzzy line. Other useful tapes are paint striping (the center pulls out), double-sided, low-tack, mending, silver opaque, colored masking, cloth, and sealing (both gummed paper and filament) tapes.

Tracing Paper, Transfer Paper, and *Acetate*—These items should be a part of studio supplies for their many applications. The outlines of

the positive shapes in two-dimensional design can be isolated, studied, and retraced. By tracing over graph paper, such a design can be reduced or enlarged. Color studies can be worked out by tracing over existing work with colored pencils and some markers.

Check tracing paper for bleed-through before use. If an aqueous medium is to be used, then a wet media or workable (mat) acetate should be used instead. Both tracing paper and acetate come in rolls and sheets and can be drawn or airbrushed on. Tracing paper and acetate also serve as protective covers for finished work on paper.

Transfer paper is used to transfer a finished design onto a ground. The paper produces a waxless, greaseless line and comes in graphite or colored transfer, in rolls or sheets.●

Health Hazards

The issue of health hazards in the airbrush studio is related to the larger question of hazardous substances in the art materials industry. Despite a growing consciousness of the dangers of environmental pollution, hazards still exist. Art materials manufacturers should provide the consumer with more complete contents labeling and warnings. Art educators should give students an awareness of these issues and should insist on proper precautions in the studio. Artists should adopt the attitude that all art materials are potentially harmful if not used properly. The discussion that follows cannot include a complete list of all the harmful materials used by artists. It is meant rather as an outline to build awareness of the health-related aspects of studio work.

Sprays

Sprays or mists are made by ejecting a liquid from a spray gun or airbrush by means of air pressure. Spray can also be generated by aerosol propellants and high-pressure airless guns. All spray mechanisms create fine droplets or particles that remain suspended in the air for many hours and enter the lungs of anyone breathing that air. If an organic solvent or other toxic substance is used, it will find its way into the bloodstream if precautions are not taken, as the toxicity of various substances is increased because of the ease by which they enter the blood, Thus, using spray without taking proper precautions is dangerous. Even if the solvent is water, as with acrylic, gouache, and watercolor, one still risks inhaling poisonous pigments or dust particles. The buildup of dust in the lungs will manifest itself as a feeling of tightness in the chest and may give symptoms similar to that of a heart attack. A further hazard exists in pointing an airless gun or any spray mechanism at the skin: it is possible to inject the paint or solvent directly into the skin where it

can be absorbed into the blood.

Inhalation—The most common way for toxic substances to enter the body in airbrush technique is by inhalation. The body has several lines of defense against this, none very effective against chemical vapors. The nose is lined with a series of hairs to trap large particles and a mucous membrane to catch some of the smaller ones. It is through the mucous membrane that toxic chemical vapors are absorbed into the bloodstream. The sense of smell does detect irritating chemicals. It should not be relied on, however, since the sense of smell is easily fatigued and not all dangerous chemicals smell bad.

Ingestion—Ingested toxic substances are absorbed into the bloodstream and may affect the liver and other body organs. The mucous linings of the trachea and bronchial tubes are designed to trap airborne particles, which are then pushed back out by natural internal cleansing action or coughing. Ingestion of foreign substances can come from coughing up and then swallowing dust particles or from poor studio habits. For example, eating or drinking in the studio may result in poisoning: hazardous substances find their way to the food as dust or vapor in the air or through hand-to-food or hand-to-mouth contact. Make it a practice never to eat, drink, or smoke in the studio. Cigarettes, as well as food, may be contaminated with hazardous substances that will then be transferred to your mouth and lungs. Moreover, smoking poses a danger of fire and possible explosion of volatile chemicals.

Other poor work habits that risk ingestion include incautious use of a mouth atomizer, placing the handle of a paintbrush in the mouth, or "pointing" the bristles of a brush with the mouth. Habits as casual as biting fingernails or placing hands in or near the mouth can introduce unwanted substances to the body.

Toxic Effects—These effects are

classified as acute or chronic. Acute effects are usually felt from the moment of exposure; chronic effects are cumulative, resulting from many exposures, and may take years to develop, depending on the substance and frequency of exposure. This is because of the slow buildup of these substances in a vital organ or the sensitizing effect some chemicals have on the body or both. Both chronic and acute effects may begin to manifest themselves as headache, fatigue, dizziness, and nausea and may be misdiagnosed as a low-grade infection. More advanced cases may see damage to the liver and nervous system. The mucous membranes of the eye are susceptible to damage from certain dusts or sprays. Most skin irritants also harm the eyes. These include acids, alkalis, ammonia, photographic chemicals, and solvents.

Hazardous Substances

Most art and airbrush studios present hazards from toxic pigments, solvents, and aerosol propellants. Many of the pigments used in the formulation of artists' paints are poisonous to some degree. Very poisonous and to be avoided are those that contain heavy metals such as lead, zinc, and mercury. Colors such as zinc and chrome yellow, chromium oxide green, and viridian may cause skin irritation and allergies and are highly toxic when inhaled. Some pigments (emerald green is one) contain arsenic and are suspected of causing lung cancer.

When ground pigments are mixed with a binder, the resulting mixture is called a paint. Binders as well as pigment may contain hazardous substances. Turpentine, mineral spirits, varnishes, and resins are present in some binders and are toxic by inhalation, ingestion, or skin contact. Acrylic paints may contain formaldehyde and ammonia, which adversely affect some people. The binder for watercolors and gouache

is usually gum arabic or gum traga-canth, which are slightly toxic. Fiber-reactive dyes, paint removers, thinners, and solvents also present hazards. Avoid skin contact with these and use them only with good ventilation. Avoid using anything containing xylene (xylol), toluene (tol-uol), or benzene without proper safeguards, as they are highly toxic. Some varnishes and lacquers may be dissolved in one of these three, making them toxic as well. Aerosol sprays may contain toluene or chlor-inated hydrocarbons. Wear a car-bon filter respirator when using these. Even though the solvents may evaporate quickly in the air, particles of pigment or resin may stay suspended in the air for hours.

Ceramic glazes are formulated with various metal oxides and com-pounds as well as free silica. These glazes should be sprayed only in a batch booth, and the artist should use a respirator.

Glass-decorating techniques may include spraying metal salts dis-solved in oil of lavender on the sur-face and refiring or spraying chlo-rides of iron, tin, and hydrochloric acid on hot glass. The toxicity of these substances demands the use of a respirator and a batch booth.

An airbrush can be used to spray enamels on copper or steel by mix-ing them with bentonite, potash, clay, and water. The enamel dusts are highly hazardous. Luster colors are made by mixing metallic oxides with pine oil resin and oil of laven-der. These oils are also toxic. Wear gloves and a respirator when work-ing with enamels and use a hood or exhaust fan when spraying.

Hydrogen fluoride used in glass etching is an irritant to the eyes, nose, and throat, and is toxic by in-halation. Symptoms can range from a sore throat to pneumonia.

Be Alert! Constant daily exposure or exposure to large amounts of sprayed material without proper pro-tection may exceed the body's ca-pacity to eliminate that substance or repair the damage from it. Smoking

1-12. Arie Galles working in studio using a respirator for protection.

or any lung disorder puts one in a higher risk group and may increase the likelihood of reactions to spray-ing certain substances. Beware of working with and spraying acids, as many give off toxic gases. Do not rely on irritation to warn of exposure; there are nonirritating poisonous gases as well, such as vinyl chloride (a known carcinogen), which is used as a propellant in some aero-sol spray cans.

Dusts are another hazard asso-ciated with spraying art materials. These light, solid particles are pro-duced from spraying pigments, dyes, ceramic glazes, and other materials. Large dust particles will most likely be trapped by the upper respiratory system and spit out or swallowed. If the swallowed dust is toxic, poisoning may result. Small dust particles penetrate deep into the lungs where they can cause physical damage to lung tissue. Mineral dusts, such as silica or as-bestos from ceramic glazes, can cause pneumoconiosis and cancer

if inhaled. Other sources of mineral dusts are carbon pigments, abra-sives used in sandblasting and air erasers, and dusts from sanding stone or fiberglass.

Studio Ventilation

The most important aspect of good studio design for any artist using spray is adequate ventilation. There are two types of ventilation, general and local. General ventilation lowers the concentration of toxic sub-stances in the air by mixing in un-contaminated air. Local ventilation is the preferred type in that it ex-hausts the spray at its source to the outside. The more enclosed the area in which you spray (see *Batch or Spray Booths and Hoods*), the better the system will be at remov-ing overspray, dusts, or vapors. The ventilation design should ensure that the contaminated air moves away from the artist's face, not past it. It should also replace as much air as it removes. If the same amount

of air is not replaced, the efficiency of the ventilation will be seriously diminished.

Fans—There are two types of fans suited for use in the artist's studio, exhaust and circulating. Exhaust fans are either axial flow or centrifugal. Axial-flow fans are generally propeller-driven, whereas centrifugal fans are of a "squirrel cage" design with a cylindrical bank of curved, straight, or radial blades. The axial-flow fan is for general ventilation, spray booths, and hoods where large volumes of air are to be moved at low velocity. Centrifugal fans are commonly used to combat dusts from sanding and grinding, for example, where less volume of air is removed but at a higher velocity. An outside vent flap or louvers that close when the fan is off should be used to conserve heat or air-conditioning.

When designing a ventilation system, keep in mind that exhaust is nondirectional. In other words, an exhaust fan withdraws air in a 360-degree area around the fan. A blower, on the other hand, is very directional, although its stream of air widens as it moves away from its source. To increase the efficiency of an exhaust system, build a baffle to fit over the fan that fully encloses the fan and has four or five slots cut out facing the direction of the spray. This modification will better direct the intake flow. Locate the work as close to the baffle as possible. Use a blower to help direct the fumes and dust toward the exhaust. A side benefit of using a blower is that it helps precipitate out of the air those particles not captured by the exhaust.

Circulating fans are axial-flow fans that may oscillate from side to side. Keeping a small circulating fan going at all times not only evens studio air temperature, but helps to eliminate dusts. The air currents generated by a fan actually serve to deposit dust particles on walls and floor. Use a fan along with other air-cleaning devices as added insurance.

When working with flammable solvents, both the exhaust and circulating fans must be explosion-proof. Make sure that the unit is well-grounded.

Air Purifiers

A further device to help keep studio air clear of pollutants is an air purifier. Inexpensive air cleaners are basically no more than fan and filter combination and should serve as a backup to ventilation or in cases where an exhaust system is impossible. Two more complex systems are ideal for airbrush studios. Ionizers, such as the Eden-Aire unit, emit a stream of ions that bombard any particles in the air and impart an electrical charge to them. The charged particles are then attracted to the walls, ceiling, and floor, and thus are removed from the air. The second type of air purifier is the precipitator, a unit that employs a series of charged plates, filter material, and a fan to trap pollutants. These plates must be removed and washed periodically, as must the filter material on some units. Both units help to keep airbrush overspray out of the air and thus out of the lungs.

Batch or Spray Booths and Hoods

Batch or spray booths are enclosed areas in which the spray process takes place. These can range in size from those that accommodate only the piece to be worked upon to walk-in industrial booths. The larger booths may be very sophisticated and include a waterfall in the rear of the booth to catch and eliminate the overspray. In spraying ceramic glazes, for instance, it is possible using such a feature to recapture and recycle a large portion of the overspray.

Exhaust hoods are usually positioned above or next to the work being done. They may be constructed with a Plexiglas front for viewing and positioned so that they partially cover the work. A basic design can be made from a large funnel or air duct connected to an industrial vacuum cleaner with the cleaner venting to the outside.

Respirators

Respirators are air-purifying devices worn over the nose and mouth to filter out hazardous dusts and vapors. They should be considered secondary to good studio ventilation, the primary concern being to get the overspray out of the studio. Respirators consist of the basic facepiece and a filtering element. In the selection of a mask, comfort and a good seal are important considerations. If the mask is not comfortable, the tendency will be not to use it. A beard or eyeglasses may make a good fit difficult; in this case, a respirator that covers the entire face with a Plexiglas viewer may be the answer. This type of mask is also recommended for use when working with any eye irritants.

The filter packs consist of a multi-layered pad made of a fiber or foam material and are rated for either dust and mists or paint spray. The mask may also have a charcoal cartridge to absorb organic vapors. Be sure to use this type when spraying anything other than water-based paint. The cartridge should be changed every two weeks or after eight hours of use or whenever vapors can be detected with the mask on. In color retouching, wear a respirator when using water-soluble dyes, adding a vapor canister if any materials containing organic solvents are used, such as spray mat lacquer. Respirators should be approved by the National Institute of Safety and Health (NIOSH).

Barrier Creams

Although keeping spray dusts and vapors out of the lungs is the most important studio health concern in airbrush technique, it is not the only

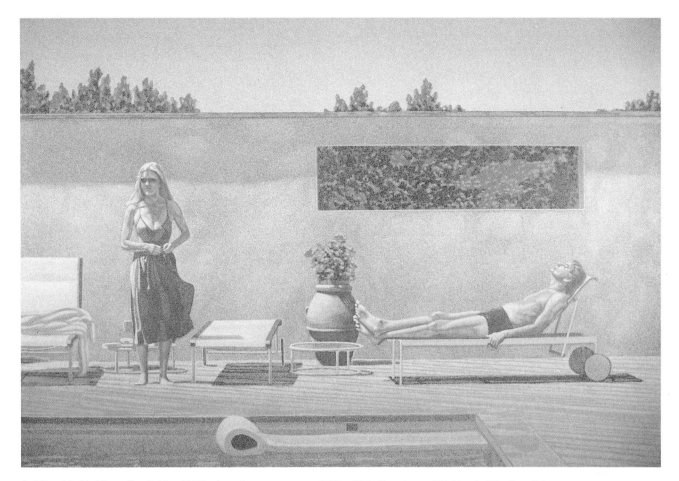

1-13. **H. N. Han**, *Poolside*, 1983. Acrylic on canvas, 66″ x 96″. Courtesy OK Harris Works of Art.

one. The artist is subjected to skin irritants and to those chemicals absorbed into the body through the skin. The best protection from these problems is rubber gloves, but where dexterity is important, as in most art processes, a barrier cream can be used. One such product is Kerodex, made by Ayerst Laboratories. It is a nongreasy, colorless cream that dries to form a strong, elastic "glove." Kerodex #71 is water-repellent to protect against irritants soluble in water and Kerodex #51 is for those insoluble in water. They are effective protection against acids, dyes, oils, enamels and lacquers, glues, photographic chemicals, petroleum distillates, and resins.

Protective Agencies

Several government agencies are involved in the testing and rating of hazardous substances and protective equipment. OSHA, the Occupational Safety and Health Administration (200 Constitution Avenue N.W.; Washington, DC 20210), was formed in 1970 to assure safe working conditions in industry. NIOSH, the National Institute of Safety and Health (Robert A. Taft Laboratory; 476 Columbia Parkway; Cincinnati, OH 45226), does research on occupational hazards. The CPSC, or Consumer Product Safety Commission (111 18th Street N.W.; Washington, DC 20210), regulates the safety of all consumer products in-

cluding art materials. They can require warning labels and may ban dangerous products through the Toxic Substances Control Act. A private group, the Center for Occupational Hazards (5 Beckman Street; New York, NY 10038) publishes a health hazards manual and newsletter.

The message here should be clear. The materials used in the visual arts and particularly airbrush technique should be considered hazardous until proven otherwise. The best studio procedure is one that includes recognition of the hazards involved in each technique and total protection from these hazards. ●

Business Aspects of the Studio

Although to most artists the production of the work itself seems most important, the fact that you are engaged in a business should be taken just as seriously. This means using basic business methods in dealing with galleries, clients, and the various government agencies. Most artists who work in their own studio will be considered self-employed or sole proprietors. Even those who work for others on a freelance or consulting basis are technically sole proprietors. Let's look at some of the considerations that face the sole proprietor in running that business.

Meeting Space

If you will be meeting with clients at the studio, you will want a specific area for this. It should not be in areas where heavy spraying is done, and if your business requires many studio meetings, a separate room may be warranted. If this is the case, use this room for business-related activities only as it will have positive tax advantages.

Telephone

The telephone will be one of your major methods of doing business or at least initiating business contact. Your business name, if other than your own, should appear in the telephone directory. A paid listing in the yellow pages is recommended. An answering machine or service is a must; some potential clients will not bother to try again if the phone is not answered, but will leave a message. The one-time cost of a machine will pay for itself quickly; an answering service is a continual expense. Although many people prefer not talking to an answering machine, people in business are used to them.

Filing Systems

Organization is important for the smooth operation of a business. Losing track of drawings, paperwork, or transparencies can be frustrating and time-consuming, and may end up costing you money. A job and a work completed file will make it easy to retrieve data on what was done, for whom, and when, as well as other information pertinent to your work. For fine artists, for example, this file could include the title, medium, size, date, and price, and a photograph of each finished piece.

You might, in addition, devise a numbering system that codes other information. For example, in 5-P-84, the first number would mean the fifth piece done in the year, the P means it is a painting, and 84 is the year. This can be altered to give the information you need. This file should also include information about any pieces sold, including the purchaser and location, who sold it, the price paid, and any commission.

A photography file can include a number of photographic items related to the work: a negative file to store black-and-white and color negatives of your work; a transparency and slide file to include color transparencies; a clip file of photographs and other printed material that may serve as an imagery source for your work. Other files should include equipment instructions and warranties, catalogs from suppliers, business receipts, and financial records. Catalog financial records by listing the date and source for all income and expenses. The expenses can be broken down into car maintenance, business travel, art materials, studio rent, light, heat, and telephone. Also keep a list of new equipment for investment credit on income tax as well as a daily journal of business activities. All of the above must be numbered and indexed in order to be useful. Personal computers are also useful in setting up and maintaining these kinds of files.

Photographing Your Work

You will need slides, color prints, and black-and-white photos of your work for publicity and promotion. The most important clues to effectively photographing airbrushed art are even lighting and accurate color rendition. The lighting itself can be as simple as photoflood lamps and clamp-on reflectors or as sophisticated as studio strobes. Photoflood lamps, although inexpensive, tend to change the color of their light output over their life. A bit more expensive are quartz lights, which may not last as long but emit a constant color (3,200° K). Both quartz and photoflood lamps have the disadvantage of being hot. Studio strobes are the most expensive photographic light source. Not only are the units, replacement tubes, and power supply expensive, but a flash meter is required to measure light output and calculate exposure. Nonetheless they have the advantage of being cool, and because the flash can be bounced off umbrellas, they provide a diffuse light with no hot spots or glare.

Regardless of the light source used, color or temperature must be matched to the film if you are photographing in color: tungsten film must be used with quartz bulbs and photofloods and daylight film with strobes. When a film that is not matched to the light source is used, the appropriate filter must be screwed over the lens and the exposure adjusted by a filter factor. The specific information on filters and exposure adjustments is given in the film instructions or is available from a photo shop. The color of the light is not as important in black-and-white photography, but the film manufacturer's recommendations on the package insert should be consulted nonetheless.

Three films that work well for photographing artwork are Kodak Plus-X black-and-white film, Kodak Kodachrome 25 ASA or 64 ASA for color slides, and Kodak Kodacolor II for color prints, all 35mm films. A

1-14. Barbara Rogers, *Chinese Moroccan,* 1981. Acrylic on paper, 30″ x 22″.

50mm or normal lens will serve well in photographing artwork. An 85mm lens, however, will cut down on light reflections from the work as seen by the camera.

Another way to reduce reflection is to use a sheet of polarizing film between the light source and the work or over the camera lens or both. These films are keyed to the polarizing direction and should be coordinated for the least glare. Do not place polarizing film too close to hot lights, as it will melt. Two lights should be set up at approximately 45-degree angles to the work so that the light from the right-hand source illuminates the left side of the work and the right side is illuminated by the left-hand light. To test for even illumination, hold a pencil in the middle of the work perpendicular to the surface. The shadows cast to the right and left should be equal. A more accurate check of even lighting is to take light meter readings of approximately nine evenly spaced areas.

The background and the stand that supports the work should be black so that they will not show in the photographs.

The same lighting and film principles apply to larger-format cameras if transparencies are needed. These large-format cameras are available in 2¼″ × 2¼″, 4″ × 5″, and 8″ × 12″ sizes. They are initially expensive but will save money in the long run if transparencies are needed on a continuing basis.

A more costly alternative is to have the work photographed by a professional. It is essential to select someone who specializes in the photography of artwork.

Résumé

A résumé supplies information about you or your work or both. It can be structured to be specific to a certain market and more general for another. It should be no more than two typed pages and can include photographs of your work. Other in-formation to consider including is education, teaching experience, grants, professional memberships, collectors, exhibitions, clients, and commissions. An alternative to a standard résumé is to have printed three or four color photos of your work on a 5″-×-7″ card with your name, address, telephone number, art representative, and other pertinent information on the reverse side.

Portfolio

In order to better market your art or your skills, you will need to show your work. This may mean a portfolio of slides for a fine artist or actual work, photographs, or reproductions of work for an illustrator. Include only your best work and arrange it so that one piece can be viewed at a time. Nothing is more detrimental to a presentation than presenting a view of all the work at once; the client or dealer may well not take the time to look at each piece on its own. It is most effective to show photos or transparencies of the work mounted separately on mat board or window mount. This makes the portfolio portable, easy to update, and professional. Keep in mind that you are usually given only a short time to present your work and show your ability.

Crating and Shipping

If your work has to be shipped, a crate must be built to protect it in transit. Most shipping companies will build the crate, but you can also have one built by a company that specializes in crating. It is best to have crates built by professionals who have the expertise to protect the piece adequately in transit.

If money is a factor and you must do it yourself, here are a few tips: first wrap the work in plastic to help protect the delicate airbrushed surface. If it is a two-dimensional piece, cover the corners of the stretcher or frame with cardboard or a stiff material. If the painting is on stretched canvas, the back should be covered with cardboard or Fome-Cor. Remove any screws and wire. The crate should be made of pine and plywood; do not use Masonite for the top and bottom, as it will not withstand punctures. The sides should be constructed of 1″-thick pine, the width to be determined by the number of pieces of work and their thickness. Make the crate larger than the work to allow room for a foam liner to absorb shock.

The side pieces should be butted, glued, and nailed, creating a frame-work to attach to the bottom. Extra protection should be given to the corners as they will take a lot of punishment: cut 4″ pieces from the side stock to overlap and nail to the outside on each corner. Metal corner braces and edging can be used for more strength.

Insert a piece of corrugated cardboard and the art into the crate, filling in with extra foam where needed. Place some packets of silica gel along the inside of the crate to help absorb excess moisture. Another piece of protective corrugated cardboard over the face of the paintings completes the packing before adding the lid.

The lid should be screwed on to make it easy to uncrate. Use enough screws all around to make the top secure. Mark "Fragile—Artwork" on the front as well as the destination and return address.

Shipping may be by truck or air freight. The advantage to shipping by truck is that it is cheaper than air and, more important, the crate will not get handled as much. Air freight, however, is very fast. Many air freight companies have toll-free numbers for pickup.

Do not forget to include insurance when shipping artwork. You may need to have the work's value substantiated by a reputable dealer if there is a claim, so be prepared.

Pricing and Selling Your Work

Pricing and selling their work are

jobs that many artists find difficult. Pricing is generally determined by the principle of what the market will bear. There are, of course, significant differences in the pricing of fine and commercial art. Pricing fine art is a difficult business but can be done intelligently. It is obvious that a fine artist cannot work out a pricing structure on a per-hour wage. There are some tangibles, however, that should affect pricing. Consider the cost of producing the piece, and be sure to include art materials as well as studio expenses such as heat, electricity, rent or a proportionate part of house expense, airbrush equipment, depreciation and maintenance of all equipment, telephone, photography, modeling fees, postage. Beyond the production costs, you may base your price on such things as your exhibition history, reviews, the collections that own your work, gallery affiliation, and how quickly your work sells at a given price range. If everything you produce sells, it is time for a price increase.

Do not be tempted to put ridiculously high prices on work that you do not really want to sell. If you are exhibiting a favorite piece, mark it "Not for Sale."

Once your pricing structure is established, it should include the highest commission that you are likely to be charged by a gallery. That way, no matter where the work is shown and what the commission is, the price will be the same. If a gallery, fund-raising group, or other institution sells your work, they have earned the commission and you are covered up to 50 percent. If you sell a piece out of your studio and employ whatever sales abilities you have to do it, then you have earned the commission.

Much of the work of establishing prices, price increases, and dealing with clients will be taken care of when and if you become affiliated with a reputable dealer. These people are professionals and make it their business to know the market

for your work. Most business relationships with dealers will require a contract to protect both your interests. Be careful in what you sign. It is advisable to employ a lawyer to make sure that you understand the terms of the contract. (See *Contracts*.)

Setting prices for commercial work is a totally different matter. Prices for fashion, book, or advertising illustration, design, and cartooning can vary depending on whether or not you are working within or near a major city. The fee the artist charges also depends on how the work is to be used. On a work-for-hire basis, for example, the client has decided to own the work and reproduction rights and can use it as many times as and for any purpose he wishes. A flat-fee contract, on the other hand, pays less but grants the client a one-time reproduction right only; the artist retains the work.

The number of people the artist deals with should be limited. Regardless of how many people in a firm are included in decision-making, the artist should try to negotiate with only one. A preliminary design including an indication of the colors and their locations should be approved with the company representative's comments, corrections, and signature. When the illustration is completed, any needed revisions should be indicated on a tissue overlay and signed again. Once these are done, the contract has been fulfilled, and any further revisions will be at an additional charge. For more specific information including suggested fees, consult *Pricing and Ethical Guidelines*, a book published by the Graphic Artists Guild.

Contracts

A contract is a legal agreement between two parties put to paper for their protection. It can be a formal document drawn up by a lawyer or a simple letter of agreement. Before agreement, there comes negotiation. For the fine artist, some areas

to negotiate and include in a contract with a gallery are exclusivity in representing your work; commission charged on sales from the gallery and the studio; discounts to museums, designers, and other purchasers; the speed at which you get paid after a sale; and the responsibility for a client defaulting on payment. Commercial artists may negotiate commissions based on the type of work (illustration, layout, paste-up, and such) and the amount of work an agent supplies. Termination of a contract is also an important issue. If either party is dissatisfied, the contract should be voidable within thirty to sixty days after signing. Further, a termination clause should be included should the gallery or representative go out of business or if a change in ownership of a gallery or agency takes place. Other items to consider are the responsibility for shipping, crating and insurance fees, the number and frequency of times your work will be shown, and fees for referring your work to out-of-state clients or galleries.

Although a commercial artist is less likely to be represented by a gallery, he may well want an agent: a contract is a good idea. An agent's responsibility is to handle the promotion and sale of an artist's work for a commission. Agents usually require an exclusive contract with the artist for the area in which they work. Agents contact advertising agencies, book and magazine publishers, film producers, and other potential clients to promote the artists they represent. A list of agents can be obtained from the Society of Photographers and Artists Representatives; Box 845; FDR Station; New York, NY 10022. The commercial artist will also want a contract with each client. The contract—or letter of agreement or purchase order—should include 25 percent of the fee paid up front, with the remainder due on delivery.

Before drawing up or signing a contract with a gallery, dealer, or agent, you may wish to consult a

lawyer with some expertise in the arts. There may be a volunteer Lawyers for the Arts organization in your area that can be of help; consult your local telephone directory. If you prefer instead to act on your own, sample contracts from which to tailor yours may be found in *Legal Guide for the Visual Artist*, by Tad Crawford, or from Artists Equity Association; 3726 Albemarle Street N.W.; Washington, DC 20016.

Juried Exhibitions

Another way to build sales and reputation is through juried exhibitions. Run by communities, museums, and art centers, service organizations and clubs, they provide exposure for your work and the possibility of an award and sales. Listings of both local and national exhibitions can be found in newspapers, arts newsletters, and magazines such as *American Artist*. Most exhibitions charge an entrance fee that is not refunded if you are rejected. They will also most likely charge a commission on sales from the show. Before entering, check whether judging is through slides or original work and who pays for shipping the work to and from the show. Other questions to be considered are if the work is insured while on display, if there is a catalog, if the show travels, has a history of sales, magazine and newspaper reviews, and who the jurors are.

Grants

Grants are a worthwhile source of funding for an artist to investigate. In many cases the only requirement is that you apply. In addition to the National Endowment for the Arts and the separate state councils on the arts, many small foundations award a number of grants annually to artists. There may be certain restrictions as to what type of work is funded, the geographic area in which the artist must work, or what

the money is used for. Information on granting agencies and application requirements may be obtained from the *National Directory of Grants and Aid to Individuals in the Arts*, available in any public library.

Workshops

Workshops offer a period of intensive art instruction. Studio space, materials, and occasionally room and board are included in the fee. Workshops generally run from one day to two weeks and are given by artists, art associations, museums, foundations, and service organizations. Lists of available workshops can be found in art magazines and through art organizations. The Small Business Administration (consult your telephone directory under "U.S. Government") and the National Endowment on the Arts (2401 E Street N.W.; Washington, DC 20506) offer workshops in the business aspects of being an artist. These usually last two days, charge a low fee, and cover grants, taxes, record-keeping, and copyrights, among other subjects. Fees for workshops are tax deductible.

Artist Colonies

Like workshops, artist colonies provide a workspace, but they do not usually include instruction and the length of stay tends to be longer, usually two months. Applicants' work is juried for admission. Some colonies charge a flat fee for room and board, some charge according to the artist's ability to pay, and others offer fellowships. One example is the MacDowell Colony in New Hampshire. Addresses of artist colonies can be found in art-related magazines.

Trade Shows

Manufacturers of art materials as well as retailers sponsor trade shows. The newest paints, brushes,

drawing tables, and other materials are displayed in booths by the manufacturers. This is a great opportunity to see what is available in the field, to talk to technical representatives about their products, and to attend seminars on the latest applications of certain products. One of the larger trade shows is sponsored annually by the National Art Materials Trade Association and is called Art in Action. National and local trade shows are advertised in newspapers, art magazines, retailers' mailing lists, and announcements at schools and institutions.

The Commercial Art Market

The market for artwork that includes the use of airbrush is vast. Any sales or promotion campaign using visuals or illustrations could include airbrush work. The largest markets in the commercial field are advertising agencies and art studios that subcontract work to free-lancers. Public relations firms, display fabricators, and institutions also have need for artwork. Other areas to look into for airbrush art are book, magazine, and greeting card publishers, fashion and product design firms, record and film companies, and audio-visual production houses.

All of these areas are open to the fine artist as well but in more limited ways. The fine artist's contact with the commercial world is usually by chance through exhibits. The work may have to be modified slightly to meet the needs of the company. Although many artists are reluctant to make these changes, commercial application of their work can mean generous rewards in terms of both money and exposure.

Taxes

If at no other time, it is at tax time that artists realize that what they do is a business. The self-employed artist makes a product, passes it on to a middleman (art rep or gallery), is

1-15. David Mascaro, *Eye*, 1983. Watercolor and acrylic on illustration board, 18″ x 24″. Courtesy Carolina Biological Supply Company.

paid for work sold, and is responsible for keeping records and paying taxes. These last two portions of the job seem to be the hardest for the artist to get used to.

Record-keeping is a must but it need be no more elaborate than writing down each expense and the income from each sale. Deductible expenses are those that are necessary to carry on the business and produce income. This means not only supplies, but museum admissions, trips to research visual information, that portion of a dwelling used for a studio, and that portion of car expenses that are business related. In other words, as an artist, anytime you do anything, stop and ask yourself, "Is this business related?" If it is, get a receipt. You will find that almost everything you do is related to the conduct of your busi-

ness, so get in the habit of asking for and saving receipts. These receipts, along with a journal, will substantiate your business deductions on your income taxes. The journal will be a day-by-day account of your business activities. If you entertain a client, write down the name and generally what was discussed. Record the date, client, and purpose of expenditure for all expenses you intend to deduct from your income.

At the end of the tax year, your art business may show a loss. This loss can be applied to any other income that you or your spouse may have had. Showing a profit *motive*, however, is important. If you can prove that you have tried every way possible to sell your work but failed, your loss is legitimate. If your business is showing a profit and you owe over $100 in taxes at the end

of the year, you must make quarterly payments.

All of this can get very confusing and may require the services of a tax accountant. An accountant can give you advice about setting up your record-keeping and what percentage of home expenses to take if you maintain your studio there, and will generally establish the tax format on which you will operate. Do not forget to take your business share of car and house insurance, car maintenance and depreciation, house heat, electricity, water, office space, depreciation of studio equipment (airbrushes, compressors), and the accountant's fee.

Two excellent methods of reducing taxable income are income averaging and a retirement account. If your business income has increased substantially over the past

four years, you may be able to average the income of the lean years with the present year, thus reducing your tax. Establishing a retirement fund is another way of reducing tax. As a self-employed artist you may open a Keogh as well as an IRA account. The money that is invested in these plans cannot be touched without penalty until you are fifty-nine and a half but is subtracted from your gross income at tax time. See your accountant or local bank for more detailed information.

Many states have a sales tax that may affect the artist who sells directly to the public. Most artists, including commercial artists, however, sell or are paid a fee through dealers, agents, and reps, and need not be concerned with collecting sales tax. If you do collect the tax, you will need a tax number with which to report it. This number will allow you to buy items that go directly into making your product (canvas and paint, for example) tax-free. The tax is collected on the completed piece of art when it is sold and paid to the appropriate state agency by the seller.

"Fear of Filing," a pamphlet available from Volunteer Lawyers for the Arts; 36 West Forty-fourth Street; New York, NY 10036, will provide more information on taxes for the fine and commercial artist.

Insurance

Coverage for business property may be too expensive for most artists to carry. Artwork owned by you can be covered with a fine arts rider on a homeowner's policy as long as the artwork was not produced by you. If you are the artist, the work is business property and must be covered with a commercial policy. This coverage can be made more affordable by insuring at one half the value of the work (as if it were sold by a gallery) and insuring only on the premises (if your gallery has insurance).

Also insure your business equip-

ment. A camera used to photograph your work will not be covered under a homeowner's policy. If your studio is in your home, add a home office accident rider. This will protect you from suits resulting from an injury sustained when a client comes to the studio. If a friend coming to visit you falls on your property, he would be covered on a normal policy. If, however, that same friend fell while on your property to purchase a piece of your work, he would not be covered. Contact your insurance agent and make sure that you are covered for losses that you cannot afford to sustain.

Copyright

Present laws state that a copyright belongs to the artist when the artwork is completed. The artist must, however, place the copyright sign ©, his signature, and the year the work is completed somewhere on the artwork. This can be on the back but must be visible if looked for. The artist can sell the work without the copyright or vice versa. The copyright remains in force for the lifetime of the artist plus fifty years. The work does not have to be registered with the copyright office unless there is an infringement suit. For more detailed information, obtain a free copyright information kit from the Copyright Office; Library of Congress; Washington, DC 20559.

Mail Order

Artists who do not have a tax number can save on local and state sales tax by ordering their art materials by mail from an out-of-state supply house. Although there will be a shipping charge, you will still save more than the sales tax if you order in quantity. Mail-order houses usually offer a greater variety of materials as well as a better price than retail outlets. The ease of catalog shopping also appeals to many artists. Some mail-order firms specialize in airbrushes and repair parts.

The drawback, however, is that of time. If you need something *now*, mail order will not do. It is best to keep a supply of materials on hand and order before running low. You may, however, be more interested in the service that a local shop gives you in terms of advice, special orders, and repair of airbrush equipment.

Attention to the business aspects of producing art will help you to run your studio in a smooth and profitable fashion. Organizing your time, correctly pricing and photographing your work, applying for grants and fellowships, and writing a professional résumé will be more than worth the time invested. The business practices mentioned here are not meant as a complete list, but one to tailor to your own situation. Once in place, these methods will give you more time to produce and promote your art. ●

1-16. Bonnie Hofkin, *Scarab*, 1981. Acrylic on board, 9″ x 14″.

Part II Software

Software is, in all systems that consume, of equal importance to hardware. In the case of airbrush technique, software may be even more important than hardware. Only by knowing the media being sprayed, the surfaces being worked on, and their compatibility with the materials being used as stencils, can the artist use the airbrush satisfactorily. To that end, let us discuss the fluids that are normally associated with airbrush technique, the grounds and supports they are applied to, and the masking materials used to develop an image.

Technically, anything that can be thinned to the consistency of light cream or thinner or is already of a sprayable consistency can be considered a spray medium. The size of pigment particles, however, varies from one medium to the next. It is important, therefore, to be sure the spray equipment used can handle the size of pigment particles and is suited to the particular application. The selection of the medium must be based on the purpose, application, equipment, desired effect, image, permanency, convenience, and toxicity. Each of these factors should be taken into consideration when a compatible medium is selected.

Covered in this section are a variety of media, from industrial paints to artists' acrylic colors, and the col-

or theories of their use. Artists tend to be experimental by nature, and many use unusual media in unusual ways. Although at times this may produce unexpected positive results, it can also produce artwork that is less than stable. It is important, therefore, to understand what various media can and cannot be expected to do.

With the increased popularity of the airbrush has come the development of colors intended specifically for use with the airbrush. These paints offer the convenience of being prereduced to a consistency suitable for spraying in combination with the permanency of a pigmented paint. ●

Color Theory

With the majority of the media used in airbrush or spray technique, color is a major concern. Color theory and the interaction of color apply, of course, to media that are sprayed on as well as those that are brushed on. There are some differences, however, in the way the color is perceived.

Basic color theory begins with the principle that color is light. It is light that carries color, not paint. The pigments in the paint or colorant absorb certain colors from white light and reflect others. This reflected color is perceived by the viewer as red, for example. But how is this red differentiated from other reds? Paint manufacturers assign arbitrary names to the colors, such as rose or scarlet. The artist, however, must be more specific in identifying color to ensure color continuity and accuracy. The system by which colors are classified and named uses the attributes of color—hue, value, and chroma. Every color can be accurately described with these three attributes. Hue refers to the name of the color. This does not mean the name of the dye or pigment used to make the color, such as hansa yellow or cadmium red, but a generic name such as red. Value refers to the lightness or darkness of a color, its position on a scale of grays from white to black. Chroma, the final attribute of color, is its relative brightness or intensity. A specific color, therefore, can be light and bright or dark and dull, and so on. For example, the color named cadmium yellow is a light (value), bright (chroma) yellow (hue); raw umber is a dark (value), dull (chroma) yellow (hue).

Many color systems are used to describe hue and chroma graphically. The basic three-primary-color system is set up as an equilateral triangle within a circle. Three primary hues—red, yellow, and blue—are located at the points of the triangle. Theoretically, all other colors can be approximated through mixtures of these three. Mixtures of two

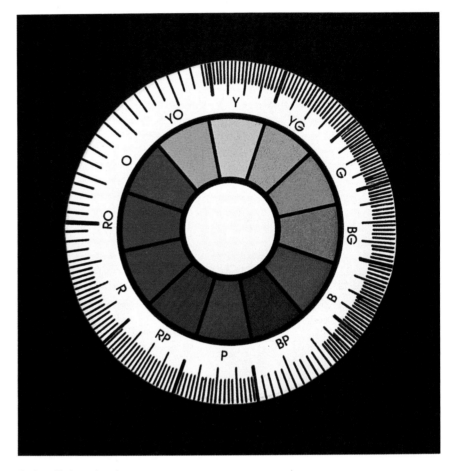

2-1. Color wheel.

primary colors (such as yellow and blue) will result in a secondary color (green), and mixtures of a primary and secondary color will produce an intermediate color (blue green). The chroma or relative brightness of a color is located within the circle. The center of the color wheel is a neutral or gray area where all colors tend to converge. As a line is drawn out from the center toward a hue location on the outer rim, that hue becomes intense. A bright fire-engine red, for example, will be located on the outside rim of the circle while a duller brick red might be located halfway toward the center. Mixtures of two colors always result in an intensity lower than that of the brightest color. The brightest forms

of all colors are commercially manufactured. It is advantageous, then, to stock as many colors as possible, even though you are able to mix them. In its brightest state, a hue can be used as is or reduced in intensity, as required. This is done by mixing small quantities of the complementary color, that color exactly opposite the hue on the color wheel. As the complement is added, the resulting color more closely approaches the center toward the gray area. If more of the complementary color is added, it will begin to take on the characteristic of the complementary hue. Mixtures of the three primary colors or combinations of any three colors that are equidistant on the color wheel (for

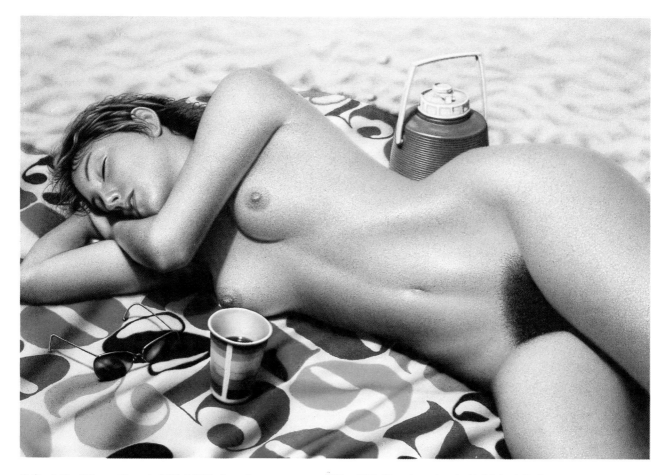

2-2. Hilo Chen, *Beach 100*, 1982. Acrylic on canvas, 38″ x 56″. Courtesy Louis K. Meisel Gallery.

example, a mixture of orange, green, and violet) is known as a tertiary color. These tertiary colors are dulled hues that are relatively neutral and tend to harmonize with all other colors.

The dimension of color value is not located on a flat color wheel such as described, but if the color model is made into a sphere, value can be indicated. The value of a color indicates its relationship to black or white. It should be noted that colors are manufactured in their brightest states at a specific value for a given color. Bright yellow, for example, is a light (high-value) yellow, whereas dark (low-value) blue is a bright blue. As colors are mixed and the value level changes, they lose their intensity.

An additional aspect of color to consider is its psychological impact. Reds and yellows are associated with the sun and warmth, and they tend to advance in two-dimensional space. Blues and greens, on the other hand, are associated with cold and serenity and will tend to recede.

Color does not exist in itself. It is the most relative medium in art and is dependent on its environment. A color of a certain hue, value, and chroma will change in appearance if its background or surrounding colors are changed. This is significant in airbrush or spray technique since color combinations are made optically instead of physically when sprayed. Although the previous color theories still apply, the artist using an airbrush must deal with the fact that new colors are created when dots of different colors are placed side by side. Even though the artist mixes the desired color before putting it in the airbrush, the final mixture takes place on the canvas. Experience will be the best guide in this matter, although much can be learned about optical mixtures (and applied to spray technique) from the pointillist painters. The surface, or ground, the transparency or opacity of the medium, the type of spray equipment used, and the size of the dot will also affect the color, and must be accounted for. ●

Paints

The major medium for airbrush is paint. Some paints are designed specifically for airbrush use; others are not especially for airbrush work but can be used if thinned.

Prereduced Paints

Airbrush Colors—Prereduced paints, designed specifically for airbrush use, are available in a viscosity suitable for spraying through an airbrush without further reduction. Prereduced airbrush colors, fairly new to the airbrush art market, are the easiest to use, and produce the best results of any medium available for the airbrush. Some examples are Badger Air-Opaque and Shivair. They are sprayable, opaque, colorfast paints designed especially for the airbrush. The opaqueness of these paints sets them apart from inks and dyes, most of which are transparent. They are also colorfast, unlike fugitive inks and dyes, so they can be depended upon to hold their color over the years. The color range offered by the manufacturers is somewhat limited in comparison to other water-soluble paints, but since the colors can be mixed, virtually any color can be obtained. These paints are quick-drying, thus enhancing their use in any application where repeated frisketing is required.

Airbrush colors are available in copolymer or watercolor base, either one of which can be worked with and mixed into paints that are not prereduced but have the same base (tube, jar color, acrylic, gouache). The copolymer-base airbrush colors dry water-resistant, allowing the artist to use a paintbrush over the airbrushed surface without moving sensitive airbrushed paint. With these colors, however, movement of the paint may occur when artists' acrylic paint is brushed over dried copolymer airbrush color because the acrylic tends to reconstitute the dried copolymer to a liquid state. The watercolor-base colors

dry water-soluble. This means they can be worked back into wet-in-wet as in watercolor technique, but of course it will not be possible to apply paint with a brush over the already airbrushed surface without picking up dried paint.

Airbrush colors are generally worked upon paper surfaces, photographs, acetate, or polyester film (Mylar). They also can be worked on a gessoed surface with some care as adhesion of this paint to the gessoed surface is not sufficient to hold up when self-adhering frisket film is lifted. Finished pieces on gessoed surfaces should be displayed varnished or under glass. Regardless of surface support, it is recommended that the original artwork be sealed with varnish, either that made especially for airbrush colors or one made for acrylic paints. Acrylic varnish should be sprayed, not brushed on. If you wish to brush-apply varnish, use airbrush color varnish, which will not disturb the tenuous airbrush surface.

Both types of airbrush colors come in easy-to-use bottles that allow the artist to fill the airbrush directly from the bottle of color. The copolymer colors can be used to tint any acrylic simply by thoroughly mixing a few droplets into the paint. Since these paints are already filtered and thinned, and since the amount of paint sprayed onto the surface determines the amount of opacity, they can be worked either transparently or opaquely.

Inks, Dyes, and Liquefied Watercolors—The general category of inks, dyes, and liquefied watercolors includes several different types of media. They are grouped together because the methods in which they are worked with the airbrush and the end results are similar. Some of the more common names for these materials are India inks, drawing inks, liquefied watercolors, airbrushing dyes, and concentrated watercolors. Their common characteristics are: (1) they are all in an airbrushable state when

purchased and do not need to be reduced further (though they can be thinned for particular effects); (2) except for black and white, the colors are inherently transparent and may have a tendency to bleed one through the other; (3) most, but not all, have a less-than-desirable amount of colorfastness. This may be a deterrent if the longevity of the original art is important.

Inks, dyes, and liquefied watercolors can be relied upon to give an extremely fine, granular spray in which the dots are virtually undetectable. This makes them ideal for illustration in which a tight gradation of color is required or when the original artwork is to be reproduced rather than itself being used.

Inks, dyes, and liquefied watercolors can be airbrushed on several different materials, but are most often used on illustration board and paper. The types of illustration board and paper are unlimited, although it is wise to work on two-ply rag surfaces, either hot or cold press. Choose illustration board and paper that will hold up well under frisketing. The tooth or texture of the material must also be considered since the atomized spray of inks, dyes, and liquefied watercolors is so subtle that it has a tendency to emphasize the texture of the paper or illustration board being worked upon. In the case of rough-textured watercolor paper, for example, the result may not give the appearance of an even spray.

Inks, dyes, and liquefied watercolors hold up reasonably well under frisketing, particularly when vinyl frisket film is used. They may all be used on treated or wet-media acetate, since the surfaces of these acetates are designed to be painted on. Special self-etching inks are available for use on standard acetate. Mylar polyester film is another material that can be worked on with inks, dyes, and liquefied watercolors. This is approached the same way as working on acetate. The major problem with both acetate and

2-3. Maureen and William Ellis, ceramic vase, 1983. Ceramic glaze, 18″ x 12″. Photo: M. Lee Fatherree.

2-4. James Havard, *The Montauk Drive*, 1982. Acrylic on canvas, 50″ x 48″. Courtesy Louis K. Meisel Gallery.

Mylar is that frisket film has a tendency to adhere so well to a smooth surface that some of the sprayed color may lift when the film is removed. Inks, dyes, and liquefied watercolors are also used for retouching photographic prints and negatives. When sprayed directly onto the photo surface, they will tint, but not opaque out any images. They hold up to frisketing fairly well on a photographic surface.

To correct mistakes and create special effects, these colors may be lightened or eliminated altogether with household chlorine bleach.

Water-based Permanent Media

Three water-based paints that were not initially designed for airbrush use—artists' acrylic colors, vinyl paints, and fabric paints—can be easily adapted for the airbrush.

Artists' Acrylic Colors—The medium most frequently utilized in the fine arts for work with an airbrush on primed or unprimed surfaces is artists' acrylic colors. They are also used in illustration as a substitute for gouache, particularly where drying time and permanency are important. Designed primarily as a quick-drying alternative to oil colors, these paints have qualities that make them compatible with airbrush technique.

Artists' acrylic colors are synthetic paints made up of a pigment suspended in an acrylic emulsion. They are water-soluble, thus making them safer to work with than oils, which require paint thinners and oil media that are extremely toxic when inhaled. Because there is no combustible solution, either in the paint or the solvents used for thinning, the overspray is nonflammable. Also, cleaning the airbrush is much simpler—only a detergent is required.

Another advantage of acrylic colors is their ability to dry quickly. This allows the artist to stencil or frisket previously painted areas quickly, whereas one must wait for oil paints to dry before restenciling. The opacity of acrylics can be modified to suit the artist: the more the paint is thinned, the more transparent it becomes. Acrylic paints are nonbleeding so mistakes can be corrected simply by painting them white and repainting over the white; the underpainting will not bleed through.

Because of its plastic base, acrylic paint is very flexible when dry. Depending on the ground, acrylic paintings can be rolled for storage or shipping without cracking. Dried acrylic paint is very durable even when sprayed in thin layers with an airbrush.

Additional advantages of acrylic colors are that they are relatively odorless, are available in various consistencies, can be applied in any conceivable method, and are less expensive than oil paints. They do, however, have to be reduced before

they can be used in the airbrush.

Acrylic medium is used in the reduction of acrylics to ensure they do not lose their elasticity and adhesive properties. Over-thinned acrylics may become unstable, cracking or flaking off the surface of the work. Because acrylic medium is thinner than the paints and somewhat thicker than water, a mixture of water and medium thins the paints at the same time as it adds elasticity. Medium comes in either gloss or mat finish. The gloss medium serves the additional purpose of giving a high or smooth finish to the surface of dried acrylic for improved adhesion when self-adhering frisket film, masking tape, or drafting tape is used. This improved adhesion ensures against bleeding and produces hard-edged lines.

Acrylic colors normally come in three consistencies: high viscosity (usually found in tubes); low viscosity (available in jars); and prereduced (available in squeeze bottles). Depending upon the consistency used, the method and formula to reduce for spraying changes. The most popular acrylic for airbrush technique is low viscosity, commonly called jar color, made by Liquitex. As a rule of thumb, the

reducing agent for low-viscosity colors is one to two parts water to one part gloss or mat medium, thoroughly mixed. Add as much reducing agent as needed to bring the acrylic to the sprayable consistency of light cream required for airbrushing. The actual amount will vary with the color. High-viscosity acrylics (such as those made by Grumbacher, Winsor & Newton, and Liquitex) are manufactured with a thickening agent that will retain the impasto of the brushstroke (imitation oil painting); it may also clog the airbrush. To reduce these colors use the fifty-fifty solution of water and medium to which is added 10 percent water tension breaker (such as those made by Winsor & Newton or Kodak).

Prereduced acrylics are less permanent than high- and low-viscosity acrylics, and they do not always produce the most satisfying results when used in the same manner as jar color acrylics. If built up to a thick layer, some tend to crack when dried. Also, the viscosity may change from one color to the next, and some colors may need further reduction to be sprayable. These colors should not be confused with prereduced copolymer-

based airbrush colors.

Artists' acrylic colors may be used on any surface common to the fine and commercial realms as long as there is a surface tooth for adherence. One of the more compatible surfaces for acrylic work is canvas, primed or unprimed, synthetic or natural. Unlike oil-based paints, acrylics contain no solvents to attack the fiber of the canvas. Paper or illustration board (either hot or cold press), Mylar, wet-media acetate, plastics, metal, ceramics, and etched glass may also be used. The pigments used in acrylic paint are colorfast and will hold up to outdoor exposure better than many industrial paints.

Since acrylics are waterproof, they can be exposed to the open air without protection by glass. Acrylics may be affected by alcohol solutions, so surfaces should be cleaned only with soap and water. After the painting is thoroughly dried, application of a nonremovable acrylic varnish to protect the painting is highly recommended. Follow with a removable varnish to accommodate restoration of contaminated varnish at a future time. (See *Varnish* for application procedures.)

Other auxiliaries that are available

2-5. Keung Szeto, *Art and Sex*, 1981. Acrylic on linen, 48″ x 120″. Courtesy OK Harris Works of Art.

2-6. **Robert Anderson**, *Stripes*, 1984. Air-Opaque on board, 25″ x 25″. Courtesy Jack Gallery.

for work with acrylics are media gels for thickening color, acrylic primers for preparing surfaces, and drying retarders to allow longer working time with the paints.

Acrylics can be sprayed through any airbrush or spray gun available and should be thought of as truly an airbrusher's paint.

Vinyl Paints—Although not as popular in the United States as in Europe, where they are more easily available, vinyl paints have characteristics similar to acrylics. They are water-soluble, fast-drying, flexible, colorfast, waterproof, and cost about the same as acrylics. Unlike acrylics, they dry to a very mat finish and have a limited color range. They are packaged in what is considered a low-viscosity consistency in tubs and jars, not in tubes. A prereduced variety called cel vinyls or cartoon colors has been used in animation for many years, the application for which they were originally designed. Since they flow evenly, they are ideally suited for back-painting acetate cels.

Like acrylics, vinyls periodically clog the airbrush. Acrylic varnish can be used for varnishing surfaces painted with vinyl. Vinyl can be painted over or lie under acrylic paints, but the two should not be intermixed; curdling may result. Some vinyls may become brittle with time.

Fabric Paints—There are two categories of fabric paints: those initially designed for work on fabric, which hold up to repeated washings; and those used by T-shirt designers in applications where speed and convenience are important. Only the first category should be considered for professional work. They come in various consistencies—unreduced for airbrushing, such as Deka fabric paint; prefiltered but unreduced for airbrushing, such as Versatex; and prereduced, such as Badger Air-Tex. For those paints that require reduction for spraying, either water or alcohol can be added. These materials are worked primarily on fabrics with a

natural fiber content for guaranteed results. All three types must be heat-set for permanency. (The color-fastness is not enhanced by heat-setting.) Heat-set either by ironing the fabric at a medium setting with a piece of brown wrapping paper over the painted area or by placing it in a commercial production dryer used in the fabric industry. If using a home dryer, refer to the paint manufacturer's instructions for setting and length of drying time. When air-brushing these materials onto a completed garment, work on a mannequin or stretch the fabric in a single layer over a piece of board; this will prevent paint from traveling through one side onto the other.

Artists' acrylic colors, though not considered fabric paints, can be used on fabric. These, too, should be heat-set for permanency. Other materials sometimes used for special colors and effects are automotive lacquers and enamels; however, these are not recommended because they are toxic and change the texture of the fabric.

Fabric Dyes—Fabric dyes are available in a large variety of colors. They are manufactured in a sprayable consistency but can be further reduced with a mixture of equal parts water and alcohol. The alcohol helps the fabric absorb the dye, and reduction will lower the intensity of the dye if softer colors are desired. Fabric dyes are transparent and must be steam-set for permanency. Most fabric dyes are designed for application on natural fibers. Some, such as Super Tinfix, are intended for use on silk and wool; others, such as Tincoton, are for use on cotton, linen, or vegetable fibers. French dyes will work best on natural fibers, although some success can be had with synthetics. Fiber-reactive dyes are used for synthetic fabrics but are extremely toxic in their dry state. This is of significance when they are sprayed, as dry particles are thus put into the environment. Proper precautions should be taken before using dyes.

When using fabric dye, use the same precautions as when using fabric paint. Bleeding from front to back of a garment should be prevented by using a block such as paper or cardboard. Unlike fabric paints, steam, not heat, sets fabric dyes. Use a steaming oven, a hand-held steamer, or the steam blast from an iron. (Be careful not to touch fabric when using an iron.) Whether using fabric dye or fabric paint, correction of mistakes is not possible; once the paint is applied, it cannot be removed without staining the surface of the fabric.

Aqua Media

Aqua media refers to a group of paints that are soluble in water and must be thinned for use in the airbrush. These include tempera, poster paint, gouache, tube watercolor. Liquefied watercolor, the sort that comes in jars, is not included here; it is a fugitive dye and was discussed previously under the heading *Inks, Dyes, and Liquefied Watercolors*. Aqua media as a group are only minimally toxic, finely ground, and quick to dry. And except for watercolor, they are opaque. These characteristics make aqua media suitable for airbrush use. They also have good adhesion and will stand up to some masking. Gouache, for example, holds up well to vinyl frisket film, whereas frisket paper may present problems.

They are available in a wide range of brilliant colors in blocks, jars, tubes, and powder form. Gouache, probably the most popular of the aqua media for airbrush use, is also available in a line of value-coordinated grays for photo retouching. They are numbered zero (white) to seven (black) with six grays in between, to be identified by the camera. They are also available in warm, cool, and neutral to match the tone of the photographic paper (one example is Grumbacher Gamma Grays). These grays can

2-7. **Ginny Brush and Susan Savage**, *Flamingo Vest*, 1983. Fabric paint. Courtesy Cow in the Kitchen.

be used to develop a metallic sheen in technical renderings.

Aqua media are compatible with paper, illustration board, acetate, Mylar, photographs, canvas panel, in fact, any prepared or unprepared surface other than metal. Gesso or polymer medium is recommended for canvas board and wood panel preparation; no preparation is needed for paper. Before painting, Mylar and acetate should be wiped clean with rubber cement remover to remove dirt and grease. Photographic surfaces need to be clean and prepared (see *Photo Retouching*, in Part III).

Aqua media are reduced with water for spraying to a consistency of light cream. They are reworkable except when mixed with a binder such as polymer medium and varnish that becomes waterproof when dry. The polymer medium binder (mixed with an equal part of water) will also give the surface some elasticity so that it is much less likely to crack. Pure aqua media, however, must be painted on rigid supports as they are fairly inflexible when dry. Surfaces should be built up as is done with acrylic, with each layer allowed to dry before the next is added. Spraying gouache too thickly increases its chances of cracking. It is essential to equip the airbrush with a moisture trap when using aqua media, as spotting may occur from water in the lines.

Most aqua media are displayed unvarnished under glass. Nonetheless, varnishes may be sprayed on without disturbing the surface to afford more permanency. Oil or acrylic varnishes may darken the paint and affect its brilliance and opacity. Some experimentation is necessary if the work must be varnished. Unvarnished surfaces may be cleaned with a solvent that contains no water. Gouache may, for example, be carefully cleaned with acetone or anhydrous alcohol.

As aqua media are the least toxic and easiest to work with of all media, both thinning and cleaning up

with water, they are the medium most often associated with airbrush technique.

Food Coloring—This is a medium mainly for cake decoration, but with some imagination it can be applied to any food product. The range of available colors is limited, but they can be mixed to create new colors. The fineness of the airbrush spray will allow the food to be colored in a variety of hues and intensities without disturbing delicate areas. Food coloring can be diluted with water to control the intensity of color.

In cake decorating, using an airbrush to apply color allows the baker to make all the frosting in white. Each cake is then airbrushed in the colors desired; there is no need to mix and apply batches of various colored icings. Use a lower pressure (about 20 psi), so the icing is not disturbed, and a fine tip for control of detail. Make stencils with brown or waxed paper, using toothpicks to hold them slightly off the surface, if necessary. Some cake decorations, such as flowers, can be airbrushed separately and then put on.

Edible sculpture made from bread dough or a collage of foods can be sprayed with food coloring to achieve various effects. Hard-boiled eggs in the shell normally colored by dipping in dye can be sprayed, using stencil techniques if desired.

Body-painting or temporary tattooing can also be achieved with the airbrush and food colors. As the colors are nontoxic, spraying them onto the skin presents no hazard, as spraying paints and dyes may.

Food coloring can also be used to color photographic prints. Use friskets to isolate the spray or apply freehand with a fine or extra-fine tip. Vinegar mixed into the color in the proportion of one-half part to twenty parts of water acts as a bonding agent. To lighten or make corrections, the color can be rinsed out of the print to varying degrees with warm water. Rinse quickly and dry. Blues and reds may be more diffi-

cult to wash out because of their staining properties, and the color will appear a bit darker upon drying than when applied. Food colors are transparent but may be made slightly opaque with the addition of white gouache (not for use on food). Fix the color with a spray photo print lacquer either in mat or gloss finish. Strongly brewed tea and coffee make an excellent sepia color for toning prints or decorating cakes without the smell of commercially prepared toners.

Oil-based Media

Artists' oil colors, although not initially designed for airbrush technique, can easily be adapted through reduction. Unlike water-based paints, oil-based paints are slow to dry, thus limiting their usage to instances in which the airbrushing is being done freehand with a minimum number of stencils or in an unlimited time period.

Artists' Oil Paint—Oil paint is a mixture of dyes or pigments with a binder of linseed oil. The binders oxidize and form a solid layer with an even distribution of pigment when the paint is dry. Oils are slow to dry, allowing the artist more time to manipulate the surface and eliminating the problem of paint drying on the tip of the airbrush. The slow drying time may interrupt the flow of work, however, as each layer of spray must be dry before the next is applied. As with traditional brush painting in oils, not following this rule may mean that the paint film will crack in the future. Airbrushing oil paints is, nonetheless, considerably faster than brush painting since the paint is applied in very thin layers, which dry faster, and the airstream itself accelerates drying.

Oil paints are compatible with canvas panels, stretched fabric, paper, illustration board, Mylar, acetate, ceramics, glass, metal, and plastics. Canvas and panels should first be primed with acrylic gesso. Wood panels may either be ges-

soed and worked upon directly or else covered with a thin muslin or paper (glued to them) over which gesso is applied. Either acrylic- or oil-based gesso can be used. One hundred percent rag paper can be painted on without priming. Copper, zinc, brass, and aluminum may be used as a ground for oil without priming; steel should first be given a coat of red oxide or zinc chromite primer. Light sanding is recommended for all metal surfaces to provide a tooth for adhesion of artists' oil colors.

Oil paint is available in tubes and can be reduced for spraying with turpentine or a prepared painting medium. Some media improve flow and drying time, but they also add hazardous vapors to the air, so safety precautions are called for. Media such as copal, opal, stand oil, beeswax, and varnish may be

added to oil paint to alter viscosity, opacity, and drying time. Impasto shapes can be formed with a palette knife using gel media; airbrush work can then be done on them. Consult the label information as well as the manufacturer's literature. Paint layers must be built up slowly and glazing accomplished by adding more medium to the paint and spraying in thin layers.

Final varnishes to protect the surface can be bought in either gloss or mat finish. The surface of a painting protected with mat varnish should not be buffed, as the wax in the varnish may give the surface a bit of a gloss. The painting must be chemically dry before varnish is applied. This means that the surface is not only dry to the touch, but that all oxidation has taken place and the paint is cured. Six months should be adequate for a thin air-

brushed surface, but more time should be allowed for thicker applications. All oil-painted surfaces should be varnished for protection. (For additional information, see *Varnish*, which follows this section.)

Solvents for oil paint are turpentine and white spirits. Clean airbrushes and other spray equipment with white spirits, paint thinner, or a turpentine substitute (which leaves less residue than turpentine). Do not allow oil paint to dry inside the airbrush as it will be most difficult to clean. (If this does happen try soaking the clogged areas of the airbrush in paint stripper. Wear rubber gloves while using any of these solvents and be cautious of inhaling the fumes. These thinners also present a fire hazard, particularly when in an atomized form. Consult *Health Hazards*, in Part I, before spraying oil paints.)

2-8. Rip Cronk, *Venice on the Half Shell*, 1981. Outdoor mural in Venice, California, 10' x 15'. Courtesy Social and Public Art Resource Center.

Alkyd Paint—Alkyds are made up of a pigment and as a binder a resin of plant origin consisting mainly of alcohols and acids. Hence the name *al-cid*, or alkyd. The paint is highly adhesive, pale in color, and transparent. It is soluble in petroleum solvents when wet, yet resistant to them when dry. Alkyds dry more rapidly than do oil paints and form a more flexible surface. Reduction for spraying is done with turpentine or mineral or white spirits in quantities to achieve a sprayable consistency.

Alkyd paint is available in tubes and is compatible with gessoed canvas and panel, rag paper primed with acrylic gesso or polymer medium, plastic, metal, and sealed plaster. Avoid highly polished or waxed surfaces; however, if they are used, surfaces should be roughed up with steel wool to provide some tooth for the paint. The preparation for most surfaces is acrylic gesso or polymer mat medium.

Spray by slowly building areas to opaqueness. Each layer should be dry before another is applied. Glazing can be achieved by extending the paint to make it more transparent, using a painting medium for oil such as Liquin or other oil media. A moisture trap is very important here so moisture does not affect the paint.

Clean up spray equipment with turpentine, mineral or white spirits, or rectified turpentine.

Alkyds are the paint of choice when spraying and an oil-based paint is required, because they dry quicker than oils. They are generally dry in forty-eight hours, but this time can be cut in half if spraying is done in thin layers. They can be completely mixed with artists' oils, which will expand the limited palette of alkyds. Alkyds mixed with oils, however, will not dry as quickly as pure alkyds.

Keep in mind that there are toxic vapors present whenever anything other than a water-based substance is sprayed. Excellent ventilation and a carbon-filter respirator are required.

Varnish

Varnishes are transparent solutions or emulsions used as coating for finished paintings to protect them from moisture, pollutants, and physical damage. Most are removable so cleaning and restoration of varnished paintings is possible. Varnishes are manufactured in two types: acrylic polymer and oil. It is recommended that acrylic varnish be used with water-soluble media and oil varnish with oil-based media. Both are available in gloss and mat finishes, which are intermixable within each type to provide a uniform finish of varying degrees and sheens. The ideal spraying consistency for varnishes is at least as thin as light cream, thinner if shorter drying time is desired. To achieve the proper consistency, some thinning may be necessary, but overthinning must be avoided, as it disturbs the chemical structure of the varnish, which may result in poor adhesion. The thinner for polymer varnish is water, and for oil varnish a mixture of one part mineral spirits to one part turpentine.

Acrylic Varnish—Acrylic varnishes, like acrylic paints, are manufactured in several viscosities. They may be thinned with water to obtain a sprayable consistency, but no more than one part water to three parts varnish should be used. With some manufacturers, the gloss varnish is the same as the gloss medium. A range of lusters can be obtained by mixing mat and gloss varnish, but do not try to mix varnishes from different manufacturers.

Although removable varnishes are available to facilitate cleaning, restoration, or reworking of the painting, it is recommended that acrylic paintings be coated first with a permanent varnish to protect the painted surface from varnish solvents.

Begin by spraying on two or three coats of the permanent varnish in a dust-free area, allowing it to dry between coats. When dry, apply two additional coats of removable varnish, allowing each coat to thoroughly dry before applying the next to prevent fogging or frosting of the clear varnish. For a more consistent sheen, spray the first coat horizontally and finish vertically. The drying time for varnish will depend upon the thickness of the varnish, temperature of the studio, and the humidity of the environment.

In addition to airbrushed work, sprayed acrylic varnishes can be used to seal and protect aqueous and other media that would normally be disturbed with a wet brush, including gouache, tempera, pastels, color pencils, watercolor, inks, and dyes. They can also be used on a variety of grounds such as watercolor and drawing paper, gessoed and untreated canvas, wood and plaster surfaces.

Sprayed acrylic polymer varnishes are universally less toxic than oil varnishes. Since acrylic varnishes dry quickly, they allow for fast protection of the paintings. Cleanup of spray equipment is quick, easy, and free of hazards, since the cleaning agent is normally soap and water.

Oil Varnishes—Oil varnishes can be used to seal and protect alkyd- and oil-painted surfaces. They can also be used on grounds such as paper, canvas, and panel to prepare the ground for painting. A removable varnish is recommended for oil and alkyd paintings since the solvent used for removal will not affect the underlying paint.

The painting must be thoroughly dry and cured before varnish is applied. During the drying period, which may be as long as six months for an oil painting and two weeks for one done with alkyds, protect the surface from dust with a sprayed coat of retouch varnish and allow it to cure in a dry, dust-free environment, possibly leaned against the

2-9. Gail MacGibbon, fan, 1983. Vegetable dyes and clear acrylic on natural fiber made from cactus, 28″ x 36″.

studio wall, with the painting surface facing in so dust will not settle on it.

Spraying varnish is recommended over brushing it on whether for picture varnishing or restoration. It is the faster and easier way to achieve a smooth, thin uniform covering, and there is no need to be concerned with the disruption of the paint surface. Of the numerous commercially prepared varnishes available, damar varnish is best for most oil and alkyd paintings because it is clear and durable. One thin coat of damar varnish is recommended for protection.

Oil varnishes must be used with caution. When sprayed, they are toxic and highly flammable, since a solvent mist is suspended in the air. It is crucial to use a respirator and work in an environment with no open flame (furnaces, space heaters, cigarette smoking). Clean spray equipment with lacquer thinner, enamel reducer, or commercial gun and equipment cleaner.

Industrial and Automotive Paints

This class of paints includes enamels, lacquers, and polyurethanes, and is oil-based. These paints can be airbrushed or sprayed onto primed canvas and board, wood or metal sculpture and jewelry, or used as an unfired final glaze on the outside of ceramics. When dry, they are inflexible, however, so their use should be limited to rigid supports. These paints offer durability and a smooth finish but present special health hazards because they emit volatile fumes. Be especially conscious of proper ventilation and adequate safety equipment. Each type of paint must be reduced for spraying with its corresponding thinner. Paint thinners are also toxic and should be used with care.

Enamels include alkyd, acrylic, and other synthetic resin enamels. DuPont Centari is an acrylic enamel that has some of the best qualities of both enamels and lacquers. It

wears well and has a good depth of finish. Imeron, a polyurethane-based automotive paint, seems to achieve the best wearing and color-fast characteristics but is extremely toxic. They should be used in place of lacquers when durability and resistance to weather conditions are of prime importance. The intensity of color may not hold up as well as water-based acrylics, but the surface will last longer. Enamels lend themselves better to spraying than brushing and will dry to a high gloss without rubbing. Their slow drying time inhibits stenciling and remasking. All work should be primed before applying enamel. Acrylic enamel will produce a hard, smooth finish without additives, but hardeners can be added for a faster application, harder finish, or a higher gloss. Use a repair hardener or an overall refinishing hardener, depending on the type of job. Consult manufacturer's recommendations for specific information. Several reduc-

ers are available for thinning the paint and altering drying time, depending on application and temperature. These are generally mixed in a ratio of one part reducer to two parts paint. Spray at a pressure of between 50 and 60 psi.

Unlike enamels, lacquers are perfect for masking and stenciling because of their short drying time. They do, however, require the extra step of compounding to achieve the sheen of enamel. Older, oil-based lacquers are being phased out of industrial applications in favor of acrylic lacquers, whose binder is a liquid plastic medium. Acrylic lacquers are among the best paints to use on metal surfaces. The paints are durable, readily available, not subject to cracking or yellowing, and easy to spray. Reducing with four parts lacquer thinner to five parts paint will yield a sprayable consistency; they can also be purchased in prethinned four-ounce containers. Acrylic lacquers are available in candy colors, pearls, base coats of rich vibrant colors, and Metalflake, a powdered metal suspended in clear acrylic that needs special equipment for its application (see *Spray Guns*, in Part I). Objects should be primed with acrylic lacquer primer and then sprayed with the lacquer at 35–45 psi.

Initial surface preparation includes finish sanding with a 400-grit paper and application of the specific preparation solution for the metal being painted. These prep solutions chemically clean the metal surface, making it more receptive to the primer. After spraying two top coats, allow twenty-four hours for drying, then wet sand with a 600-grit paper, wipe clean with a tack cloth, and coat with a clear acrylic lacquer or enamel.

In two-dimensional fine art, clear lacquers have been used as a final picture varnish. We do not recommend this as lacquer tends to disintegrate over time with exposure to the sun. A better choice is clear

polyurethane, which may be used as a final varnish over acrylic paints, prereduced airbrush colors, pastels, pencils, gouaches, inks, dyes, and watercolors. Available in aerosol cans, polyurethanes with a UV filter can be sprayed on work to give it a glossy, wet look.

Bleach

Bleach is used in commercial art and in photo retouching to adjust the value and intensity of color. It is effective on watercolors, dyes, inks, and color or black-and-white photographs. Diluted household bleach may be used; there are also commercial bleaching solutions for photo retouching that combine several ingredients with the bleach for specific effects (feathering, vignetting, and highlighting). Bleach is generally applied with a brush or cotton swab but may be applied with an airbrush for a specific effect. A stipple pattern, for example, or gradual reduction in color intensity can be achieved by spraying bleach on the work.

Mount the work on a horizontal drawing board so that bleach will not drip or run into other areas. Dilute household bleach with at least half as much water. The process is fast-acting, and dilution gives a bit more working time. It is always advisable to test the colors used with the bleach solution before applying it to the work. Once bleach is applied, the effect cannot be reversed. Lightly mist the areas of interest, watching the effect closely. If further reduction of color is desired after the first application is dry, another application may be necessary. Certain colors are more reactive to bleach than others and may lighten more quickly. Colors that are resistant to bleach may have to be lightened with white gouache or acrylic. Areas that need highlights may be dotted with a drop of bleach from a brush handle or toothpick.

Bleach works to lighten areas of all types of photographic prints. Col-

or prints, however, present a special problem, in that bleaches tend to be color-specific. That is, certain colors will react and lighten when bleach is applied, leaving residues of other colors in the print. Retouching Chemicals Company offers a bleaching solution called All-Off, which will lighten all colors in an evenly controlled manner without color shifts or residues. Bleaching solutions are also available for specific colors, as well as black and white and for specific types of prints such as C-prints, R-prints, or dye-transfer prints.

Both household bleach and commercial bleaching solutions are corrosive and reactive with other things besides pigments and dyes. Some bleaches may soften the acetate or vinyl on friskets and stencils. Test the materials before use. The paper board, too, may be softened if the bleach soaks in through any deep cuts from the stencil knife. Maintain a light touch in cutting stencils so the frisket is only scored and the board is not cut into at all. The airbrush also will suffer some corrosion from the bleach if not flushed well with water after each application.

Bleach is an eye and skin irritant, and the artist is advised to take proper precautions when following the above procedures. Good ventilation and the use of a respirator are essential when spraying bleach. ●

2-10. Don Eddy, *C/VI/B (Mickey in Half Moon Midnight)*, 1982. Acrylic on canvas, 31" x 40". Courtesy Nancy Hoffman Gallery.

Grounds and Preparation

The choice of grounds or supports (the surface to which a medium is applied) and their preparation depends upon the purpose of the work, the desired effect, and required longevity. In theory, a medium can be sprayed onto any material that will hold it. Many surfaces need to be treated in some way before the medium is sprayed on it. Such preparation is, in most cases, intended to fill in the pores of the support and provide a smooth surface. As the airbrush is usually associated with smooth transitions of color, texture is an important

consideration in selecting a ground and its method of preparation. Other aspects to consider are durability, absorptive quality, and flexibility of the surface. A ground should be durable enough to stand up to the given application. For example, for illustration, the ground must be able to stand up to masking with tape and frisket films. A ground that is too absorbent for a particular medium may allow a color to "sink" in, making it difficult to establish areas of opaque color. The flexibility of a ground should be matched to that of the medium being used. A hard, inflexible paint applied to a flexible surface may develop cracks over a period of time. This is caused in part by expansion and contraction of the surface from changes in temperature and humidity.

Unusual surfaces should be tested for compatibility with the medium to be used since certain ground and medium combinations may react to or resist one another. Delicate surfaces and media, such as hot-press illustration board and gouache, may be affected by oil from the artist's hand. This may stain the surface of the medium or

act as a resist to it, so care should be taken. Grounds and their preparation should be considered as important as the medium and the airbrush technique employed to apply it. The ground imparts character to the medium, holds and displays the image, and is in part responsible for its longevity.

Paper and Illustration Board

Paper is probably the surface most worked upon by an artist. Depending on the medium being used, selection of the correct paper is a relatively easy decision, for most papers are marked for medium (watercolor paper, print paper, charcoal paper, and so on). There is, however, no such thing as airbrush paper. The artist has to seek out a paper or board that is suitable for this particular technique.

Papers are made either by hand or by machine. Sizes are added to the paper pulp and to the surface of the paper for added strength. When the paper is made, it is dried and pressed on felt blankets against drying cans. The felt side of the paper is the top. Then the paper is sized again for strength, dried, and put through a series of rollers to smooth the surface of the paper. Tooth is determined by the pressure of the rollers and the number of times paper is put through rollers.

Of the three common methods used in working with an airbrush on paper, the most common is with adhesive-backed frisket film, second is nonadhering stencils, and third is freehand. With frisket film, choosing a paper with adequate surface strength and tooth is important to ensure that the surface does not pick up when the frisket is removed. With stencil and freehand techniques, any paper can be worked upon as long as the medium is compatible with paper. Any medium that is airbrushable will be compatible with any paper. In general, a 100 percent cotton rag paper

is stronger than paper made from wood pulp or other products. The fibers themselves are more durable, and the size put into a 100 percent rag drawing or bristol paper seems to be ideal for work with frisket film.

The tooth of the paper may also cause problems. Frisket film will adhere totally to a very smooth hot-press or high-surface paper, increasing the possibility of surface lift when it is removed. In addition, it is more likely that the surface of a hot-press paper will be scored when the frisket film is cut, and there is a greater chance of the paper lifting or tearing where the surface is cut. Care should be taken when removing frisket film from any paper, but particular caution is urged with high-surface paper. On a medium-surface or cold-press paper, lifting problems are less likely to occur. Because of the slight tooth on the surface of cold-press paper, there is never total adhesion.

The surface of a paper, whether high or low, can alter the final effect. The tooth of medium-surface paper will give a slightly more granular effect than that achieved on a high-or smooth-surface paper. Adhesive-backed frisket can be left on a cold-press surface longer than on a hot-press surface but is still not recommended for periods over four to six hours.

Canvas

In the selection of canvas for airbrush work, the most important considerations are texture and permanence. Historically, the survival of paintings on stretched canvas is far superior to those on rigid supports, and restorations, when needed, are more successful. Artists' canvas is manufactured from linen, cotton, jute, and blends of natural and synthetic fibers. Linen is superior in strength to cotton, but does not have the consistency of texture that is important for airbrush work. Jute is unacceptable because

of its coarse weave. When choosing a cotton or linen canvas, look for a portrait quality with smooth texture and uniform weave. All synthetic canvases have these qualities.

Canvas must be primed before use. For those interested in the traditional methods of canvas preparation, see *The Artist's Handbook of Materials and Techniques*, by Ralph Mayer.

True gesso is a chalk or other inert white substance bound with glue, gelatin, or casein and used as a white ground. Synthetic or acrylic gessoes are ready-to-use liquid grounds that have a polymer emulsion base and can be used on any support. They are flexible, non-yellowing, and can be easily reduced with water to a sprayable consistency. Acrylic gesso is recommended for preparing surfaces to be painted in airbrush technique. If a tinted ground is desired, a small amount of acrylic color may be mixed in. Prime the canvas after it has been stretched or mounted. Using a brush to apply gesso will give a somewhat streaked surface. A smooth finish can be obtained with one of two methods. If the air source will handle the larger volume of air needed to operate a spray gun, the gesso, thinned with a fifty-fifty mixture of water and polymer medium, can be sprayed on. The second method of achieving a smoothly primed surface is with a paint pad. Available in hardware stores and designed for house painting, these synthetic fiber pads are washable and reusable. They distribute the gesso evenly in a fashion much like a window squeegee. In fact, a squeegee can also be used for this procedure. Working with the stretched canvas flat on the floor, pour the gesso directly onto the canvas. Spread it across the surface in a thin, even coat using the pad or squeegee, working quickly and taking care not to move back into the drying gesso. Allow drying time between the two coats, sand with 400-grit paper to provide better

2-11. Ben Schonzeit, *Portrait of the Artist without Glasses*, 1980. Acrylic on canvas, 72″ x 60″. Courtesy Nancy Hoffman Gallery; collection San Antonio Museum of Art.

adhesion for successive coats and a smoother finished surface, and reapply, alternating between horizontal and vertical strokes with each coat.

It is also possible to buy commercially prepared gessoed cotton, linen, or synthetic canvas. These canvases are available with single- or double-primed surfaces and in many different weights and weaves.

For most airbrush applications, use the finest uniform weave you can find, as the texture may interfere with the tightness of the image. One such fine-weave prepared synthetic canvas with good strength and stretch characteristics is Amazon, Style 1595, made by Fredrix. For some applications a coarse-weave canvas may add desirable effects such as catching the spray with one color in one direction and another color in the opposite direction. Pre-primed canvas requires canvas pliers for stretching, as it does not have the give that raw canvas does. It is a good idea to give an extra two or more coats of gesso to commercially prepared canvas after stretching for added durability and a smoother surface.

Whether preprimed or raw canvas, if a completely smooth eggshell surface is desired with no trace of the canvas weave, finish off with wet sanding. Using a fine wet-dry sandpaper on a sanding block or orbital sanding machine, sand in a circular motion. Occasionally add water with a spray applicator or mister. This will begin to break down the gesso into a paste that will be spread around by the sanding motion. Continue to sand as the water evaporates and the gesso becomes smooth, hard, and fills in the texture of the canvas. Do one small area at a time until the entire surface is smooth, repeating the operation until you are satisfied. Wet sanding will smooth out the gesso no matter how it was applied, but it is much more difficult to smooth out dried brushstrokes. At this point the surface is smooth but very absorbent. Paint applied to this surface may tend to sink in, and frisket films will not stick. Spraying a few coats of polymer gloss medium will seal the surface and provide good adhesion for friskets, tape, and paint. If the surface is too glossy to draw on, a further light sanding with a fine-grit paper will correct this.

Occasionally changes in temperature and humidity may cause a stretched canvas to sag. This problem can be alleviated with an airbrush and water. Simply spray several coats onto the back of the loose area and allow to dry. The canvas will shrink upon drying and tighten the affected corner. If the back is inaccessible, as in sculptural stretched pieces, and if the medium is acrylic, the front can be sprayed with similar effect. Do not

2-12. **Peter Mackie**, *Figure III*, 1980. Acrylic on canvas, 64″ x 48″ Courtesy Jack Gallery.

use too much water as the stretcher may warp from an uneven pull. Start with small amounts and watch the effect upon drying. Accelerate the drying by blowing air on the damp area, and repeat the process if necessary. This procedure will not work with synthetic canvas, nor is it recommended for an oil painting because of the inflexibility of the surface. In either of these cases, use corner keys, protecting the back surface of the painting with a piece of cardboard while tapping in the keys.

Panel Board

Panel boards can be purchased ready-made or fashioned by the artist. Commercial canvas boards are made of cardboard covered with gessoed canvas. They come in only limited sizes, have a tendency to warp, and are rough in texture. Regessoing for a smoother finish increases the likelihood of warping. These panels are not recommended for professional use. Gator Board, Fome-Cor, and AA plywood can be prepared directly with gesso or be mounted with canvas or other materials and then prepared. All of these panels should be attached to rigid supports to prevent warping. The supports can be built from 1"-X-2" stock wood, cut to the same size as the panel and glued on with epoxy or wood glue. Prepare the surface by sanding and priming with acrylic gesso applied by roller, paint pad, or spray. Follow the procedure described for stretched canvas, allowing each coat to dry before sanding and applying the next coat. This provides a smooth and rigid support for airbrush work. Tempered Masonite is not recommended for this direct application of gesso because the oils and silicones used in its manufacture may stain the paint surface as well as interfere with the paint ground bonding. Untempered Masonite, however, is suitable for this application.

2-13 and 2-14. Roland Dempsey, *Animation Cel*, 1983. Acrylic on acetate and illustration board, 12" x 18". Two stages of painting an animated cel.

Canvas, paper, or synthetic-based graphic arts materials such as DuPont Tyvek can be glued onto the surface of these boards as well as to tempered and untempered Masonite. The canvas need not be heavyweight; signcloth, which has a fine weave and smooth surface, is sufficient. Use a glue designed to bond concrete and plaster to other materials (available from a building materials supplier) since it is not affected by water. A water-base glue might be redissolved as water from the paint seeps through the canvas.

These rigid painting surfaces are ideal for airbrush work, since it is easier to attain an extremely smooth gessoed surface than on canvas because the panels are flat and rigid and provide a better surface to sand against.

Acetate

Acetate is a transparent plastic material available in both mat and gloss finishes in varying thicknesses. It should not be confused with Mylar, which is more durable and harder to cut. Acetate has two functions in airbrush technique—as a ground to be painted onto and as a material used for stenciling. (See *Masking Materials*.) Since acetate is transparent, it is ideally suited for opaque and transparent projection, as a transparent overlay in illustration, and as a cel in animation. Acetate comes in both sheets and rolls and in various colors, which can be used to paint on or cover airbrush work. Sheet acetate will lie flat, whereas acetate in rolls may tend to curl. Roll acetate, on the other hand, is available in very wide widths and long lengths.

The type of acetate primarily used as a ground for these purposes is called wet media. It has been pre-etched to be receptive to paints, inks, dyes, and other liquid media. Somewhat more expensive than regular acetate, it is available in a multitude of thicknesses and sizes. The thickness chosen is determined by the application, though most applications call for a thickness that makes it somewhat rigid (3–6 mils). Regular acetate can be painted on with various inks that are self-etching. Both types of acetate can be worked upon with frisket film, but frisket papers have a tendency to adhere too closely and leave a residue on the acetate surface that will show up in the work or in the reproduction of the work.

Acetate can be back-painted, as in animation, to develop a smooth, even background and can be drawn upon and painted on the front to develop images or highlights. In photo retouching, acetate is used to extend backgrounds and for ghosting out objects without painting on the original print. (See *Photo Retouching*, in Part III.)

Mylar

Mylar, the name given to DuPont's polyester film, has some of the same characteristics as acetate: it is plastic, clear, available in sheets or rolls but it has significant differences. It is much more durable, which makes it an easier surface on which to cut frisket. It will not stretch when self-adhering material is removed. Mylar in a mat surface gives an excellent tooth for paint to adhere to. And, of course, there is no paper lift with which to be concerned as with acetate. Mylar in a gloss finish, however, does not give good adhesion.

Mylar can be bought with a photosensitive surface, on which line drawing can be developed, depicting the area to be airbrushed.

Paint can be washed from Mylar with soap and water with no adverse effect to the polyester film material. Mylar does not yellow or become brittle with age. Mylar of at least 0.005 thickness is an excellent surface on which to apply all media available for airbrushing, and should be investigated for use in fine arts especially.

Acrylic Plastic Sheets

Plexiglas, an acrylic plastic sheet manufactured by Rohm and Haas, can be used as a ground in spray technique and incorporated into three-dimensional sculptural designs. Both sides can be painted, the transparency of the ground and its thickness providing an added dimension. Plexiglas is available in a variety of thicknesses and colors. It is supplied with protective cover sheets on each side. The cover sheets can be used as friskets so long as the artist takes care to cut into them lightly without digging into the Plexiglas surface.

Before any media are applied, the surface must be thoroughly cleaned with a cleaner designed specifically for use on Plexiglas. Sanding the surface before painting will provide

a tooth to aid paint adherence, but only those areas to be painted should be carefully sanded if the transparency of the surface is to be preserved.

Artists' acrylic colors can be used on Plexiglas but have a tendency to lift when frisket film applied over the paint is removed. Best results are achieved with automotive paints. These can be thinned to a sprayable consistency with the appropriate reducer. Thinning reduces the opacity of the color, however, so care should be taken not to overthin.

Fiberglass

Spray or airbrush technique on fiberglass is usually used in automotive and sculpture applications. Artists' acrylic can be used with good results; Blaise Batko's twenty-five-foot sculpture is an example. (See Figure 2-15.) The surface, however, must be prepared if the acrylic paint is to stick: thoroughly sand the smooth surface of the resin to provide a tooth for the paint. Then wash down the surface with water to remove all dust, and allow to dry. Next, spray on a primer-sealer intended for use under water-based paints, such as Mantrose-Haeuser Enamelac. When dry, sand lightly and spray on a coat of acrylic gesso to complete the surface preparation. Artists' acrylics can now be applied to achieve the desired color effects. For outdoor sculpture, spray on a protective coat of urethane varnish with a UV filter. Some urethanes have a strong yellow cast to them, so test on white paper before using.

When spraying oil-based paint on fiberglass, first sand the surface with an 80–180 grit paper. If there are any bits of glass fiber not coated with resin, use an epoxy primer such as Eliminator (Morton Paint). Otherwise, use either a lacquer or enamel primer and follow with a fine sanding. Either lacquer or enamel paint can be used. Nonsanding

2-15. Blaise Batko, *Meltdown*, 1982. Acrylic on fiberglass, 26'.

primer-sealers are also available, but only enamels can be used over them. For colorfastness, an important consideration with outdoor sculpture, enamels are superior to lacquers, although they lack the depth of finish that lacquer achieves. Enamels need not be rubbed and buffed as they dry to a high finish; lacquers must be buffed. On the other hand, imperfections in lacquers can be rubbed out through buffing whereas they dry into enamel surfaces and must be painted over. Spray technique can be used to prepare molds for casting fiberglass

sculpture. Before the fiberglass is laid into a plaster, polysulfide, or urethane rubber mold, polyvinyl alcohol is sprayed on to act as a separator between the resin and the mold.

Metal

The best paint for metal surfaces is acrylic lacquer, an extremely fast-drying plastic-based paint. (See *Industrial and Automotive Paints*.) The application of paint on metal surfaces in spray technique is similar to that of fiberglass. Surface preparation begins with sanding and finish-

ing with a 400-grit paper. Follow by washing the surface with a prep solution for the particular metal being used to remove any oils from the surface and prepare it for the primer. Use either an enamel or lacquer primer; if the metal is steel, use a red oxide primer. Sand with a 400-grit or finer paper after the primer is dry. Spray the top coats, allowing twenty-four hours to dry. Then wet sand with a 600-grit paper, wipe clean with a wet cloth, and add a final coat of clear acrylic lacquer or enamel if desired. ●

2-16. Layne Karkruff, *Night Before*, 1983. Acrylic on illustration board, 18″ x 24″.

Masking Materials

Whenever an airbrush is used to spray paint around, over, or through an object, a silhouette is left when that object is removed. The object used to block the spray is called a stencil or frisket. It is used to achieve a hard-edged line and to block the drift of overspray color onto unwanted areas. In airbrush technique many things are used to make stencils—from pieces of intricate lace to photo process silk screens. The most commonly used method to develop an image where stenciling is needed is with adhesive-backed frisket film.

Friskets

Frisket is a transparent or translucent self-adhering material that is cut in airbrush technique to make stencils directly on the surface of the work. Frisketing and frisketing techniques can be quite complicated, but they are essential to airbrush technique and can be considered an art in themselves.

There are three types of friskets in use today: homemade frisket, adhesive-backed frisket paper, and adhesive-backed vinyl frisket film.

Artists have been making their own paper friskets as long as they have been using the airbrush. A thin coating of adhesive, most commonly rubber cement, is applied to the back of translucent onionskin or tracing paper and allowed to dry before the paper is applied to the artwork. The artist usually coats as many sheets of paper as necessary for use on a given project at one time. This can be time-consuming and is the first of many deterrents to making one's own paper friskets. Once the prepared sheets are applied to the artwork, the area to be painted is cut out with a very sharp knife; care must be taken to avoid cutting into the surface of the work. (This can be accomplished only with practice.) After the area of the frisket is cut and lifted, the rubber cement that remains on the surface of the work must be completely re-

moved. Residual rubber cement can be removed with a finger, a kneaded eraser, or a rubber cement pickup. Always assume that there is some rubber cement on the surface of the work, and scrutinize it thoroughly. Problems may arise if the rubber cement is blocking the sharpness of the stenciled edge and if removing rubber cement from delicate surfaces that have been painted with gouache or watercolor results in smudging or lifting of paint. Once the area to be painted is completed, the remaining frisket must be removed. Again, be sure to check the newly uncovered surface thoroughly for leftover rubber cement. Taking this cumbersome procedure into consideration, this method of frisketing can be extremely frustrating and time-consuming, although inexpensive.

Adhesive-backed frisket paper is available commercially in sheets and rolls. The adhesive backing of the frisket is covered by a protective sheet of paper that must be removed before the frisket can be applied. The backing is easy to peel off: start by slipping the blade of a knife between the backing paper and frisket at a corner, then simply peel off the backing.

The strength of the adhesive on frisket paper varies with manufacturer and time; both frisket paper and backing breathe, and the adhesive may dry out over a period of time. From sheet to sheet and also from one end of a roll to the other, the tack may change greatly. Choose a surface that is strong enough to resist lifting when the adhesive-backed frisket paper is removed and be very cautious when applying frisket paper to paper surfaces that are not 100 percent rag. Adhesive-backed frisket papers have a tendency to buckle and warp when sprayed upon. This happens when paint is built up to an opaqueness with overlapping passes along a cut edge; it may cause an inconsistency in the hard-edged line by allowing paint to bleed

underneath. Frisket paper tears easily, so if a stencil is to be reused, it should not be left on the surface of the work for more than four to six hours, and a great deal of caution must be taken in its removal.

Adhesive-backed frisket films, the newest and most popular of the frisket options, avoid many of the practical problems outlined above. Available in rolls and in sheets, they are normally made of a 2-mil vinyl that has a light tack adhesive. This adhesive is then covered with a protective sheet that must be removed before use. In some brands of frisket film, a scored tab runs along one edge for ease in removing the backing. Unlike frisket paper, neither the backing nor the vinyl film breathes, which prevents drying out and gives the frisket film an indefinite shelf life. The type of tack on the frisket film makes it much more compatible to a range of paper surfaces and there is no need to fear that the surface or artwork will lift when the frisket is removed. It can also be applied to gesso surfaces if gloss medium has been added to the gesso. Used and cut in the same manner as other friskets, frisket film resists buckling when sprayed upon and does not tear as easily as frisket paper. It can be removed from the artwork in one piece and replaced onto the backing paper for later use. Since vinyl frisket film does not dry out, it could well be usable six to eight months later. Although frisket film is initially more expensive than frisket paper, the reusability of the cut stencils and unused pieces makes them equally economical. Frisket film is available in both mat and gloss finishes. The gloss finish is crystal clear, whereas the mat is translucent and may distort the view of the artwork slightly. Mat film was originally designed to be drawn upon although we do not recommend doing so. Wherever a pen or pencil is pressed on the film, an undue amount of adhesive residue will be left on the surface of the work and

2-17. **M. Pickel**, untitled, 1983. Fabric dye on silk. Courtesy Maureen Labro, Savoir-Faire, Sausalito, California.

2-18. **Arie Galles**, *Uncle Sam*, 1983. Acrylic lacquer on aluminum, 74″ x 50½″. Photo: James Dee; courtesy OK Harris Works of Art.

therefore show up after applying paint.

Acetate

Another material which is used as a frisket or stencil in airbrush technique is acetate. The proper thickness of acetate to use for stenciling is 5 mils, at which the acetate is not too flimsy for handling nor is it so thick that the edge will block the airbrush spray. Unlike frisket film, which has to be cut through completely to be removed from the surface of the artwork, acetate is merely scored with the sharp knife, bent at the score, and broken away. This gives a sharper edge than cutting through the acetate and prevents the possibility of cutting into or through the surface of the work. Once the acetate stencil is cut, it can be used over and over again, making it an ideal material for multiples such as those used in T-shirt designs and for the reworking of any type of technical illustration. This can be beneficial when a great deal of time is consumed with cutting intricate stencils for a technical illustration and the job is sent back for further enhancement or repair.

Acetate has no adhesive backing. To hold it in place, the artist either uses weights or applies adhesive. To apply adhesive to acetate, use either rubber cement thinned with rubber cement thinner or replaceable spray adhesive, which is available in aerosol spray cans. Both should be applied in a thin coating and allowed to dry for a minute before placing them onto the work to prevent the possibility of leaving residue on the work. Neither is entirely satisfactory, however, since inevitably, small particles of the rubber cement or residue from the spray adhesive will be left on the surface and appear when the area is sprayed with ink or paint.

The preferred method when working with acetate is to use weights, the function of the weights is to hold the acetate in place as well as to keep the stencil closer to the work. There are four different ways to do this. The first and simplest is to do the rendering flat on a table. This method requires an airbrush that can be sprayed straight down (side- or gravity-feed or oscillating). After having cut and registered the stencils, place the weights (washers or other metal objects) around the perimeter of the area to be painted. This is a fairly easy method of working with acetate and gives satisfactory results. The second system of weighting acetate stencils allows the artist to work at an angle of forty-five degrees or steeper. Cover the drafting table or drawing board with a piece of 1/8″ sheet steel and use as many small but strong magnets as required to hold the stencils in place. Magnets suitable for this use are readily available from mail-order houses or hardware stores in an assortment of sizes. The third method requires covering the work surface with a magnetized vinyl drafting table cover and setting pieces of steel of various sizes and shapes around the acetate stencil to hold it in place. These coverings are available at art and drafting supply stores and are rather expensive. In the fourth method, acetate stencils can be held to the surface by a static charge created by rubbing with tissue paper. For semi-soft-edged lines (shadows), hold the acetate stencil slightly off the work.

Using acetate without an adhesive coating eliminates the risk of lift or picking of the paper surface when it is removed, even from the most delicate of surfaces. Also, the stencil can be lifted for viewing the progress of the work that is blocked by overspray and to check the continuity of the work.

Continual lifting of a stencil, however, increases the possibility that it will be replaced out of registration. This can be prevented by lipping the acetate with drafting tape and attaching the tape to the top of the work before cutting the stencil. In this way the acetate can be lifted as often as needed and dropped back exactly into place. When more than one piece of acetate stencil is needed to complete a given job and reworking is a possibility, up to four sheets of acetate can be hinged to a given work surface at one time. Another method of holding acetate in place is by perforating the acetate with a hole or leather punch. These perforations are placed around the perimeter of the area to be airbrushed. Tape is then placed over these perforations, thus holding the acetate in place. In many cases the artist simply holds the acetate stencil in his hand and moves it while spraying for various effects.

Water-soluble paint that builds up on an acetate stencil can be removed with soap and water or Air-Opaque cleaner. Unlike a paper stencil, the acetate stencil will not deteriorate from repeated cleanings. Acetate stencils also will not buckle from having wet media sprayed upon them. The washability and reusability of acetate stencils make them suitable for multiple work, such as that encountered in fabric design.

Mylar

Mylar looks similar to acetate but, as a stencil material, does not work nearly so well because it is not as easy to cut. Most Mylar stencils are die-cut in various patterns and based on a specific theme—Christmas, Valentine's Day, Early American, and such. Mylar stencils can be held in place in the same manner as acetate stencils, either with adhesive or weights. They are more durable than acetate, but are limited by available precut designs.

Liquid Frisket

Liquid frisket is a pigmented rubber latex solution sometimes known as art masking fluid or Maskoid. When dry, it is a water-impervious film that acts as a mask to dyes and paints. The pigment is intended to indicate

2-19 and 2-20. **Peter West**, *666*, 1977. Formica and acrylic on Plexiglas, 5′ x 2′ x 2½′. Front and side views.

where the liquid has been applied, but some indicator pigments may stain certain papers, so it is best to test the application before use. It can be easily removed by peeling or rubbing in the same manner as rubber cement. Be careful to remove all residue from the work.

Liquid frisket can be sprayed on a ground and be followed by a sprayed application of color. This will result in a negative effect, keeping the ground color masked out where the frisket has been applied. It can also be used in this manner in watercolor technique to keep the brilliant whites of the paper free from color in order to establish clouds and highlights. It can be employed in photo retouching to achieve a soft effect, for example, between a model's hair and the background.

Art masking fluid is available in a sprayable consistency. If art masking fluid has begun to dry out in the jar, it can be reconstituted with water as a solvent/thinner. Cleanup is with soap and water or window cleaner.

Miscellaneous Masking Items

Because anything that is airbrushed around, into, or over will leave a silhouette of that shape, the possible range of stencil materials is vast. This section will cover items not normally thought of as stencils—anything from tape and stick-on price tags to found objects.

Tape—Tape is the most common of all the items that fall into this category. Since they are adhesive-backed, tapes are ideal for working in airbrush technique. Available in long rolls, they are ideal for airbrushing of hard-edged lines and straight bands. The types of tapes used in this technique are masking tape, drafting tape, and plastic art tape. There are some specialty masking tapes available in automotive paint supply stores. Some have peeling strips that enable the artist to achieve either a positive or negative

band from 1/16″ to 1″ wide.

Masking tape is highly adhesive and is not recommended for use on paper. It can be effectively used, though, on gessoed surfaces or painted or unpainted surfaces where there is no possibility of surface lift. Drafting tape, on the other hand, is of the lowest usable adhesion and can be used on both hot- and cold-press paper surfaces. Masking tape and drafting tape are both made of paper and, therefore, can be bent into curved shapes as long as the curves are not too tight. The narrower the tape, the more bendable it is. Check the edges of the roll of tape for any dents, lint, or other particles before using; these imperfections will give an inconsistent edge when the tape is used. Drafting tape is available in ½″-, ¾″-, and 1″-wide rolls; masking tape is available in widths of ¼″ to 5″ and wider. Plastic art tape has an extremely exacting edge that, when sprayed along, gives a razor-sharp line. It too comes in ¼″, ¾″, and 1″ widths.

Tape edges do not have to be sealed before spraying to prevent bleeding of paint under the tape. Tapes may leave a sticky residue on very smooth surfaces, such as high-gloss acrylic, Plexiglas, or hot-press illustration board. This residue may be removed with lighter fluid or rubber cement remover, which will not harm the working surface.

Templates—Manufactured templates intended for drafting can be used as stencils as well. They can be found in many sizes and in every conceivable geometric shape from ellipse to French curve. Most are made of plastic or metal, which makes it easy to wash dried paint from them. Templates can be held in place by hand or with magnets or tape. Take care not to paint too heavily along the edge of the template since a capillary action may draw paint up under it. The thickness of the template should be taken into consideration since the thicker the template, the more likely

that it will block some of the spray going onto the work, resulting in a less than hard edge. Most templates have more than one opening; make sure those openings not being used are covered with paper to protect them from overspray.

Stick-on Shapes—One of the overlooked areas of potential stencil shapes for airbrush technique is stick-on shapes. These adhesive-backed pricing labels, letters, numbers, type, or cartoon characters may be used as stencils on everything from medical illustrations to T-shirt design. They are ideally suited where multiples of one object are sought. Test to make sure the tack on the item to be used as a stencil is compatible with the surface on which you are working. Adhesive-backed shelf paper can be used as a masking material on metal, glass, and plastic surfaces. This material can also work well as a frisket on gesso. Some of these items may leave a residue of adhesive on the surface of the work, which can be removed with lighter fluid. None of these items should be left on the surface of the work any longer than frisket film.

Found Objects—The list is endless. Look for objects that have a very intricate pattern that, if used rather than cutting a frisket, would save much time. This could include objects from the studio, nature, office, and home, such as templates, leaves, stick-on labels, and lace. It is a good idea, when such an object is found but not required for immediate use, to put it in a file for future reference. ●

2-21. Al Grove, technical illustration, 1983. Air-Opaque on illustration board, 20″ x 30″.

Part III Applications

Not long ago in the history of airbrushing, a list of applications associated with the airbrush as an artist's tool would be quite short. Today that list of applications is long and ever-growing. Since anything that can be liquefied to a certain viscosity can be airbrushed, it is easy to see why the airbrush has grown in popularity and uses. All the airbrush does is spray paint from one point to another. It is the methods, systems, and techniques in combination with the talent and imagination of the artist that has made airbrushing responsible for so many of the visual images around us today.

There are as many ways of working as there are artists, and the methods used are a matter of practicality and preference. The masking system used to develop a technical illustration can easily be applied to sharp-focus realism and vice versa. Do not be trapped by predetermined notions or labels into a single way of working. The applications described in this section represent a broad spectrum of possible utilizations. ●

Painting

In painting with an airbrush the emphasis has been put on realistic styles. The airbrush, however, is used in all styles of painting, each with its own particular technical and aesthetic problems and solutions. In this discussion of painting, several approaches to develop both realistic and abstract images are explored.

Certain unique problems arise in realistic work because of the effects desired, which include no evidence of brushstrokes, intricacy, and photographic illusion. The most important elements in achieving a smooth, nonbrushed look is the surface of the ground. The texture of the surface to be painted on must be right before painting begins. The sprayed paint from the airbrush will reveal and enhance the texture of the surface being painted on. A smooth, tight-weave canvas surface is a must for the degree of detail required in the airbrushing of a realist painting. The smoother the texture of the surface, the more photographic the airbrushed effect. Moreover, extensive use of frisketing techniques demands a smooth ground so that the frisket film will adhere well and give a clean edge. The painting used to demonstrate this approach is *Peaches and Pools*, by Robert Anderson. The canvas used in this painting is Fredrix Amazon, a polypropylene-based, acrylic-primed canvas that has excellent stretching qualities. Its smooth gessoed surface and regular weave make it an excellent canvas for this type of airbrushed image. The gessoed surface of the Amazon canvas is thin and not a bright white, because some of the brown texture of the synthetic material shows through. This can be left unpainted and used in areas that may call for an off-white color. The canvas can be lightly sanded with a fine-grit paper to smooth the surface a bit more. (For an eggshell surface, it must be wet-sanded; see *Grounds and Preparation—Canvas*, in Part II.) Cardboard placed between the stretcher and the back of the can-

3-1.

3-2.

3-3.

3-4.

vas avoids an edge line being sanded into the canvas from contact with the stretcher. The canvas may sag a bit from the pressure of sanding but will tighten again since synthetic canvases have a memory.

In painting clothing, the weave of the canvas can be allowed to show through, giving a heightened reality in simulating the texture of the material. Glazes of transparent color can be airbrushed over these areas without losing the textural effect. For a brighter white background, acrylic titanium white can be sprayed on without changing the smooth areas of the surface. The artists' acrylic used in *Peaches and Pools* is Liquitex jar color thinned with one part polymer gloss medium and two parts water, as described under *Paints—Water-based Permanent Media*, in Part II.

Most paintings have a background with a predominant color (see Figure 3-1). Spraying the entire canvas with this predominant color before drawing the image will save a frisketing step and, because of the reduction with gloss medium, will provide a smoother surface for the adhesion of frisket film. A general drawing is begun with pencil at this point, outlining areas of color in the background, with no attention to detail. Figure 3-1 also shows this as well as the outline of the figure to establish its placement.

The order of painting these images is forward from the point farthest back in space. In other words, paintings are built in sections that may overlap as their relative position moves toward the two-dimensional plane. For this reason, the figure will be done next to last and the dress will be done last. This creates a greater sense of reality in placing it over and in front of the

3-1 through 3-5. Robert Anderson, *Peaches and Pools*, 1983. Acrylic on canvas, 50″ x 50″. Five steps in development. Courtesy Jack Gallery.

background as it naturally occurs. Adopting this approach and analyzing each painting step minimizes the cutting of friskets (the most time-consuming aspect of this type of airbrush painting). Although the background in *Peaches and Pools* is a flat backdrop and all the elements are at the same level, the back-to-front method should still be used. The pools were painted first, and because the background elements are rather far apart, each pool was frisketed separately. Using paper to mask areas around each pool instead of frisket film saves on film. Had the background been more complicated, the entire area would have been covered with frisket film. In any case, never cover more area than you can expect to complete in one work period. That way you will not have to leave the film on overnight, a poor practice since its adhesion to the paint surface increases with time. Smooth out and burnish the frisket film after applying. Use the edge of a small plastic ruler, for example, to eliminate any air bubbles and in-crease the adhesion of the film to the surface to prevent paint from bleeding under the edges. As each new color is airbrushed, the friskets of the color just completed must be replaced and a new area opened up. The paint must be thoroughly dry before the frisket film is replaced, or it will pull up the paint when the film is finally removed. In Figure 3-2, for example, the blue of the pool area was recovered when thoroughly dry before the white reflections were sprayed in. All of the cuts for all color areas to be painted in one work session should be made before any spraying is done. Once the frisket film begins to get covered with overspray, it will be very difficult to find the lines for the next series of cuts. Some frisketing procedures become very complicated with many cuts. Numbering each piece with a permanent marker as it is cut and removed will simplify its replacement. As each piece of frisket

3-5.

film is removed from the canvas, set it aside on its backing paper. The backing paper will help prevent the frisket film from drying out and its adhesive from picking up contaminants.

The entire background is developed in this manner: color by color, back to front (see Figure 3-3). Acrylic paint was used in the entire painting except for the narrow lines that radiate out from the pools, which were done in Air-Opaque applied with a drafting pen. Mix more acrylic paint than you think you need for any given color area and save leftovers in a jar or 35mm film canister. You will always need some extra color, and it will be very difficult to mix and match later. Before using a stored color mixture, stir thoroughly as acrylic paint has a tendency to separate from its reducer. If there is any skin or mold on top of the paint, remove it before mixing. Be careful to spray over the edges of the frisketed areas, rather than at them, to help avoid bleeding.

Building up a color too quickly will also cause the paint to bleed under the frisket film.

Figure 3-4 shows the chair, the next closest object to the picture plane. Because the chair was to be painted over several colored areas, it was important that the junction of these areas show no paint ridges. Paint ridges are caused by the build-up of paint along the edge of the frisket film; it must be scraped down with a razor knife before an image (in this case, the chair) is painted over them. If this is not done, an outline of the image underneath will be distractingly visible. For scraping, an X-Acto #19 blade works well as the flat blade can be held parallel to the work surface. In general, scrape and touch up the edges of all areas to give the painting a more natural, less "frisketed" look. Care should be taken not to scrape any area so hard as to change the surface texture. This sudden smoothness will be as distracting as the raised edges. Figure 3-4 also shows the

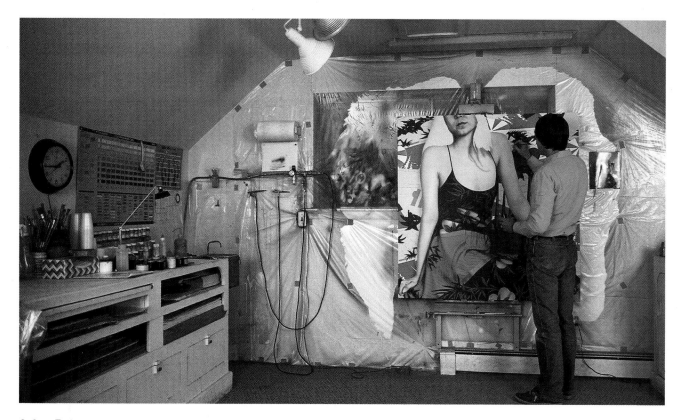

3-6. Robert Anderson working in studio on *Peaches and Pools.*

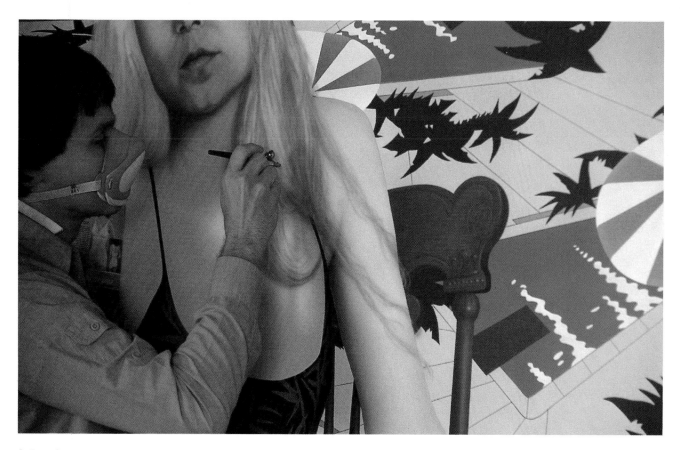

3-7. Close-up of Robert Anderson working in studio on *Peaches and Pools.*

shadow cast from the figure onto the background. Painting in this shadow at this point saves a frisketing step, as any overspray onto the figure area will be painted out in the next step.

In Figure 3-5 the female form is developed, as it occurs next in space. The entire area was first covered with frisket film, and those areas to be painted flesh were cut out. Some of the long straight areas, such as the arms, can be masked off with tape and lipped to paper to catch the overspray. This is a bit more economical than frisket film. Always overmask areas, as the drift of paint overspray is deceiving. Use drafting tape in this case, however, as many brands of masking tape have a strong adhesive that may lift delicate airbrushed areas or leave adhesive residue on the work.

The approach to painting the figure is the same as that of any other dimensional object. Begin by spraying on a middle-value local color. In this case a flesh tone was sprayed into all areas where the skin was to be painted. Build up the color slowly toward a flat opaque, allowing each coat to dry thoroughly before applying the next. Draw in the features, paying particular attention to outlining the shadow areas. These areas will give the object dimension and reality. Mix the shadow color by using a dark or lower value and dull or lower intensity of the local color. In the case of flesh, burnt umber is mixed with some ultramarine blue to lower its intensity. (See *Color Theory*, in Part II.) Other incidental colors, such as any reflected or natural color variations, are sprayed on at this time. In flesh tones, for example, areas such as the cheeks and knuckles appear a bit redder. The last elements to give the object added dimensionality are the lights and highlights. These are made by mixing a high value of the local color (that is, lighter; do not confuse with the photo retouching value scale) or by using white. Depending on the light source that created the

highlights, they may contain a warm tint. The more highlights are used, the more the object will look shiny, reflective, or wet.

The arm on the left-hand side of the canvas in Figure 3-5 presents a minor spatial problem that could be more complicated in other compositions. The lower part of the arm is behind the dress, whereas the upper part is in front of the dress. A similar problem exists wherever a form is half in front of and half behind another form, like the links of a chain; this calls for careful analysis before painting. The area farthest back in the picture plane should be painted first. The successful painting of these, in particular, calls for proper drawing and perspective and attention to edges and shadows. In our example the inner edge of the upper arm must be softened against the dress when the dress is painted. The lower or forearm should appear as though behind the dress. This is achieved by airbrushing a shadow onto the arm as though it were cast by the as yet unpainted dress.

The painting of the dress is approached in the same manner as the flesh. In this case, however, there are a number of color areas rather than one. Each area is laid in as a flat opaque color, the shadows and highlights being reserved for the last step. The lines in the dress are done in the same way as the lines in the background. The flesh and background areas should be covered to protect them from any overspray of the dress colors. Figure 3-6 shows the completed dress. The artist is softening the edges of the skin with a paintbrush to keep them from having a crisp, cutout look. The edge is first carefully scraped with a razor knife and then softened further with paint applied with a fine-line bristle brush. In Figure 3-7 the hair is begun by laying in a flat local color, frisketing off only those areas of the face that need to retain the hard-edged line that separates the face from the hair. Many times one side of a face will show

the hard edge of the cheek and jawbone and require frisketing to retain that edge. The opposite side may have hair that appears as though it is in front of the face and should be airbrushed freehand, as is the rest of the hair. This is a tricky frisketing problem, and caution should be taken not to paint the hard-edged lines too far or to pick up the ghosted image of the frisket film shape with overspray. After establishing the flat local color, begin adding the darker hair color for modeling. Do this using two or three different dark browns that vary in hue as well as value. To keep the hair from appearing too soft, finish it by adding fine lines with a small round sable brush and by carefully scratching in some hair lines with the point of a razor knife. This scratching technique allows the underpainting to show through.

The completed painting (Figure 3-8) has been protected with three coats of varnish, a fifty-fifty mixture of polymer gloss medium and mat varnish sprayed on in three thin layers. Dust off the surface of the painting first with a draftsman's brush to make sure the painting is free of particles. Let each layer of varnish dry thoroughly before applying the next so as not to cause fogging. (See *Varnish*, in Part II.)

The end result of this method of painting is to develop subject matter on a surface totally free of brushstrokes. It is composed of paint sprayed on an eggshell surface and coated with a sprayed varnish. The images are composed of tight, frisketed hard edges that dictate where they exist in space. These edges can be achieved only with the use of a stencil.

In some paintings the images are developed by freehand airbrushing without the use of hard-edged lines. Such paintings appear soft in focus (depending on viewing distance) because of the innately soft sprayed line of the airbrush. Some realist artists using freehand technique use the airbrush to spray individual dots

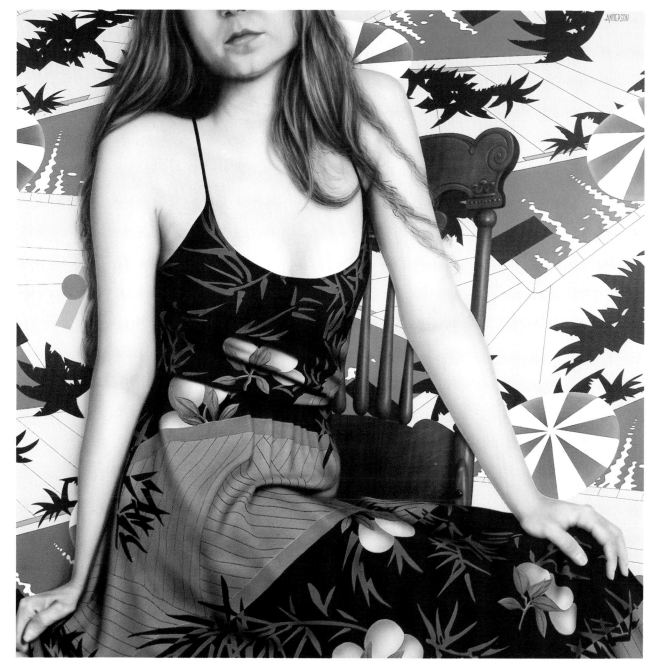

3-8. *Peaches and Pools.*

3-9. Don Eddy, C/VI/E, 1982–83. Acrylic on canvas, 60″ x 78″. Courtesy Nancy Hoffman Gallery.
First stage: thalo green underpainting.

3-10. *C/VI/E.* Second stage: burnt sienna overpainting.

3-11. *C/VI/E.* Third stage: dioxazine purple overpainting.

3-12. *C / VI / E.*

or dot units (solid dots, dots, circles, squares) that mimic the pattern of a color separation. Don Eddy's painting *C/VI/E* (see Figures 3-9, 3-10, 3-11, 3-12) was rendered entirely freehand in four different stages, each stage done in a different transparent acrylic paint, all of which combine optically to give the appearance of a color photograph.

When airbrushes or spray guns are operated at the proper pressure, the dot pattern is as small as it can be. When the air pressure is reduced, the dots get larger and the pattern erratic, producing a stippling effect. This effect is used to denote textural differences in illustration (a metal casting as opposed to a high-sheen area). It is also used in color field painting and mechanical pointillism, as in H. N. Han's *Poolside* (Figure 1-13). This type of image is achieved with nonadhesive waxed-paper stencils that are loosely attached or hand held to the canvas to establish exacting shapes without hard edges. Working from dark to light, the artist applies sprayed dots over the work. The underpainting is done with a paintbrush in solid colors.

In the paintings discussed thus far, the airbrush or spray gun was used to develop all or most of the painting. Many artists, however, use the airbrush in only a small portion of their artwork, in conjunction with other methods of applying paint. In the acrylic painting *Remember Izzy Zimmerman* (Figure 3-13), by Robert Paschal, the airbrush was used to develop specific effects in isolated areas only. The types of canvases and grounds used in such expressionistic paintings are a matter of artist preference, since the paintings are usually very thick and utilize brushstrokes. Some of the shapes in this particular painting were made by pouring acrylic paint or spreading the paint with a paint pad. A pregessoed synthetic canvas was used; it was backed by and stretched over ⅜″ A-C plywood. A-C plywood is finished smoothly on

only one side, and care must be taken to make sure the surface is free from particles, which will show up under the stretched canvas. The plywood backing keeps the canvas from sagging with the weight of the painting when work is done flat on the floor, and avoids dents when a paint pad pushes against it. All the freehand shadows that appear in this painting were developed with the airbrush (Figure 3-14). The brown area that appears to float in front of the painting is actually the raw canvas. The soft, granular spray used for the shadows in this area was also used to make two-dimensional shapes look three-dimensional (Figure 3-15). The flat orange shape was frisketed out, and the dark gradation used to make it look three-dimensional was sprayed in. The already cut frisket stencil was then shifted slightly to one side, and the shadow of the now three-dimensional-looking shape was sprayed in.

Another way to use the airbrush is in the development of exacting hard-edged lines (Figure 3-16). This is achieved by spraying along strips of tape—drafting, masking, or, in this instance, plastic art tape, which has an unblemished edge for achieving an extremely sharp line. Because the tape is not wide enough to block all the overspray, a masking machine can be used to lip masking paper to the tape to catch all the overspray. Masking machine paper is available in fifty yard rolls 3″, 6″, 9″, or 12″ wide. Take into consideration the amount of overspray when selecting the width of paper to use.

In some instances in abstract illusionistic painting, the shapes that appear in or seem to levitate in front of the painting are made away from the painting surface and then applied to it. In the paint collage by Robert Paschal (Figures 3-18, 3-19, and 3-20), the white and purple shapes were made by pouring acrylic paint onto a clean sheet of glass. After the paint had cured, airbrush shadows and highlights were

applied to the shapes. The overspray caused by the airbrush drifted onto the glass and was left behind when the shapes were peeled and removed. A single-edge razor blade was used to start peeling the dry paint shapes. These shapes can be moved around the picture plane to develop the composition before being attached. After position has been established, the shadows of the shapes can be sprayed in before the shapes are attached. When attaching an acrylic shape to an acrylic painting, use acrylic gel medium as the adhesive. When the shadow appears adjacent to the shape, indicating that it is lying on, and not in front of, the two-dimensional plane, both the shadow and the dark side of the shape can be airbrushed at the same time with the shape attached to the surface of the painting. The airbrush may also be used to repaint an acrylic color shape if a change of color is wanted.

Extremely hard-edged and technical images lend themselves to being developed with acetate stencils. Any medium can be used with an acetate stenciling system. (See *Masking Materials—Acetate*, in Part II.)

The Badger Twentieth Anniversary logo, executed by Al Grove (Figures 3-21, 3-22, 3-23, 3-24, and 3-25) is an example of the use of an acetate stencil system painted with opaque media. The image to be airbrushed in this case was drawn on a sheet of vellum. The image could alternatively have been statted to size or transferred to the vellum with transfer paper. The background of the illustration is black, so a black hot-press (smooth) illustration board was used, thus eliminating the need to paint the background. Because no adhesive is used on the acetate, the list of possible surfaces is endless and the picking quality of the board does not have to be taken into consideration.

The vellum drawing is laid over the board and taped down on all

3-13. Robert Paschal, *Remember Izzy Zimmerman*, 1983. Acrylic, urethane, and Air-Opaque on canvas, 48″ x 96″. Courtesy Isis Gallery.

four corners to keep it from shifting out of place. A piece of acetate the same size as the work surface is lipped with drafting tape to the top of the illustration board. Another piece of acetate is attached to the bottom, and a third is attached to the left-hand side. All the acetate stencils are thus hinged to the edges of the board. In this way they become flaps that can be lifted and looked under and then laid back into place without a shift in registration.

The acetate hinged to the top of the board is laid over the drawing, and the area to be cut out of the acetate for use as a stencil is

scored but not cut through with a stencil knife. When selecting the area to be scored, make sure the areas are not adjacent to each other and that the areas to be scored are of a number and size that does not make the acetate too flimsy. In the first stencil, the number *two* and the letter *t* are scored. When the area to be used as a stencil is scored, the acetate is removed from the surface of the drawing and the acetate is bent at the cut marks, breaking it away and leaving a stencil opening with an exacting hard-edged line. This scoring, lifting, and bending is repeated

until all stenciled areas are open. Cutting the stencils one after the other before any painting is done ensures registration.

After the drawing is removed from the board, the first stencil is draped down over it for painting. It has to be held down tightly to the board with one of the three systems described under *Masking Materials—Acetate*, in Part II. Once the stencil is weighted or taped down, the painting can begin.

Painting on a black background requires the use of opaque paint (acrylic, gouache, or airbrush color). The local color is the first to be

3-14 through 3-16. *Remember Izzy Zimmerman*, details.

3-17. Ruth Hardinger, *Plexus 1*, 1984. Mixed media wallpiece, 54″ x 38″ x 17″. Courtesy Max Hutchinson Gallery.

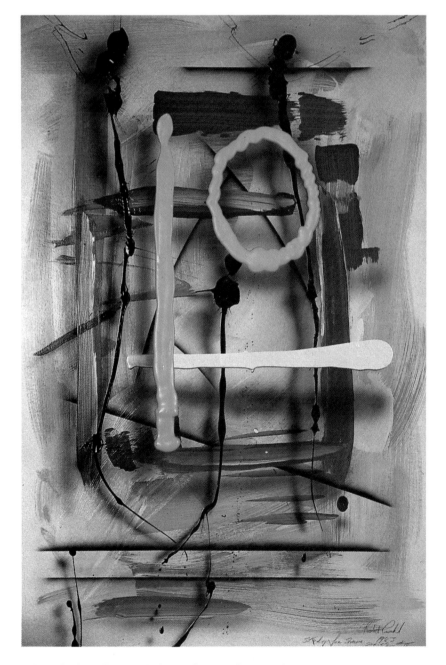

3-18. Robert Paschal, *Study Stream Series #3*, 1983. Acrylic on illustration board, 30″ x 20″. Courtesy Isis Gallery.

3-19. *Study Stream Series #3.* Acrylic shapes to be applied to painting.

3-20. *Study Stream Series #3.* Painting onto which acrylic shapes are to be applied, with shadows of the shapes already painted.

sprayed. In this particular illustration, it is used in four large areas. Therefore, a large amount of this color should be mixed so no new mixing and matching is required if the color runs out in the middle of the job. Also, some color may be needed to cover overspray that may occur later on. Build up the opaque local color in slow, overlapping passes. Do not spray too much paint too quickly. After the local color was developed in the *two* and the *t*, the color in the airbrush was changed and the shadows and highlights airbrushed in. Once the paint was dry, the weights or pieces of tape were removed from the stencil, and the stencil lifted off the artwork. This process was repeated until all the images were painted, the work progressing in order from the area farthest back into the painting out to the two-dimensional plane.

Within the last stenciled area to be painted, the logo shield, an impression of metallic sheen was required. Using warm and cool colors adjacent to each other is a common approach to achieving reflective images. It is essential when trying to develop the reflective image of any object to paint the image scene "within," not "on," the object doing the reflecting. What can be seen in the logo shield are the shapes and colors of things in its environment. The shapes reflected can be either abstract or real, and normally the local colors are muted. For instance, when a metallic shape is painted, not only is the three-dimensionality of the shape taken into consideration, but so is the fact that everything around it is part of the reflective image in the shape.

In essence the airbrush can develop only two types of painted effects—stenciled lines, either hard or soft; or dot gradations of varying sizes. Individually, combined, or in conjunction with other painting methods, these are the elements that are used in all airbrush paintings.

3-21.

3-22.

3-23.

3-24.

3-21 through 3-25. Al Grove, Badger Twentieth Anniversary logo, 1983. Gouache and Air-Opaque on board, 30″ x 40″.
Step-by-step illustration executed for the Al Roberts Design Studio.

Photo Retouching

Most photographs used in major advertising promotions (fashion, product, and technical) are altered and enhanced through retouching with an airbrush (Figure 3-26). In fine-art photography the photograph can be used as a ground on which to paint (Figures 3-27, 3-28, 3-29, 3-30, 3-31). The internal-mix airbrush can mimic the surface and grain of a photograph and is, therefore, the type of airbrush recommended for photo retouching. Both black-and-white and color photographs can be retouched with an airbrush using a variety of media. Depending on the desired effect, gouache, acrylics, or prereduced opaques can be used for eliminating or adding, and inks or dyes can be used for tinting. Photo retouching can be done on either fiber-base or resin-coated stock.

The first step in photo retouching is to study the print and take into consideration any special instructions. It is helpful to have a copy of the print as a backup in case of mistakes or for reference while retouching the original. The size of the reproduction will determine the size of the print to work on. Generally, the work print should be one and one-half to two times larger than the reproduction size. This way of working keeps the final image tight. This is not as critical for newspaper reproduction, where the screen size is coarser (#60) than in magazine reproduction (#120). Another consideration is how the retouched photograph is to be separated. If a laser-separating process is used, the separation should be done from a color transparency of the retouched work, as the laser scanner will otherwise interpret the retouching separately from the photograph, and that will adversely affect the final reproduction.

The first step in retouching is to mount the photograph on a single-ply paper board (use museum acid-free board for fine-arts applications). Mounting can be by dry-mount tissue, spray mount, rubber cement, or double-sided pressure adhesive. Make certain that the board is free from any particles that may leave small bumps in the photograph and show up in the retouching. When mounting, leave a border of at least 2″ around the photograph for attaching stencils, handling without touching the photograph, and making notes to the printer. Keep these borders as free from overspray as possible. Clean the photograph with a tissue and rubber cement thinner. The surface can then be given a tooth by gently rubbing it with rubber cement thinner and cotton in a circular motion. This will also remove any photographic chemical residue, fingerprints, or dust that may interfere with or resist the retouching medium.

In standard photo retouching the airbrushing is done directly on the surface of the photograph with materials that are water-soluble when dry (dye or gouache). These media are correctable, and the overspray can be removed with water without affecting the photo emulsion. When working with a waterproof medium (acrylic or Air-Opaque), it is best to first seal the surface with a spray mat lacquer. This allows for their removal, if need be, with a cleaner such as Air-Opaque Cleaner without streaking the photo emulsion. The mat lacquer also provides a better tooth for the adhesion of retouch media.

In photo retouching, as in all airbrush technique, a stencil is needed if a hard-edged line is desired. Stencils can be made of 5-mil acetate, vinyl frisket film, liquid frisket, hand-held stencils, or torn paper. If an acetate stencil is used, one side should be taped to the border to hold the registration. After the stencil is cut, it can be held to the surface in one of the three ways, as outlined under *Masking Materials—Acetate*, in Part II.

When using frisket film on photographic paper, there are two considerations. The first is that care be taken not to cut into the surface of the photograph; the second is that a very tight bond will be developed between the frisket and a glossy paper. To avoid this, mount the photograph and spray it with mat lacquer. Take extreme care when removing the frisket not to lift the emulsion.

Stencils can also be made from kitchen plastic wrap and rubber cement. The rubber cement is first applied to the photograph around the shape to be covered; the plastic wrap is laid onto the rubber cement and formed to the image to be stenciled. When dry, the rubber cement on the photograph but not attached to the plastic is removed with a pickup and the area is ready to be sprayed. No cutting is involved with this technique, and therefore there is no opportunity to score the photograph. The edge achieved is soft.

When spraying onto a photographic surface, build up the layers of medium slowly. Photographic paper is not very absorbent, and applying the medium too quickly will cause it to run and bleed under any stencils. All opaque media used in photo retouching should be built up to opacity in thin overlapping coats. Spraying on these media too thickly will develop an undesirably rough texture and a high image edge. If an image edge does develop, it can be softened by lightly rubbing an eraser or fine emery cloth on it.

For retouching of black-and-white prints, sets of value-coordinated grays are available in either tubes or prereduced in jars. The values are numbered from zero (white) to seven (black) and can be intermixed for middle values. They are available or can be mixed in warm, neutral, or cool. These grays may be used in color photo retouching to develop metallic sheens or to establish achromatic images to be rephotographed and then retouched in color.

In either color or black-and-white retouching, it is recommended that matching be done by testing on a scrap piece of paper, letting it dry,

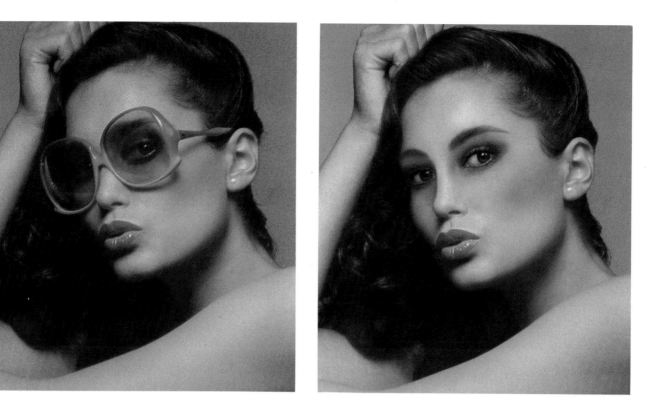

3-26. Yeou-Jui Szeto, fashion photograph used as a portfolio piece, 1983. Before and after color retouching. The glasses are opaqued out, and skin tone is reestablished.

and holding next to the area to be retouched.

For work on a physically damaged surface or to extend the background of a photograph, a technique called windowing should be employed. In this process the retouching is done on a sheet of wet-media acetate laid over the photograph. Wet-media acetate has a delicate surface and should be handled with care. It is designed to be painted on, not to be used as a stencil. Do not rub this type of acetate to achieve a static cling, as it will damage the surface. Rather, attach it to the board by taping at diagonal corners. This allows the retoucher to lift the unattached corners to compare the progress of the work with the original photograph. The image to be windowed, or allowed to show through the retouching, is masked out on the acetate overlay with either acetate or frisket film. The areas to be retouched are then sprayed out on

the overlay. When the stencil is removed, the subject image will show through the acetate window with the background opaqued; the retoucher will never have touched the surface of the photograph. This process is helpful in product retouching and is useful when art is to be rephotographed for reproduction. The camera will not record any difference between the photographic surface and the surface of the overlay.

Although good results can be achieved in color retouching by working opaquely with gouache or acrylics, some chemical retouching techniques may be required as well. Most professional color retouching will be done on either Kodak dye transfer or Ilford Cibachrome prints. To retouch these prints chemically requires using bleaches for the specific cyan, magenta, and yellow dyes used to make the print; some total bleaching of areas may be required as well. (See *Bleach* in Part II, for more information.) Apply the

bleach with a cotton swab or an airbrush, and rinse off with water when the desired effect is achieved. Frisket film or liquid mask can be used to isolate an area to be bleached. A solution of one part polymer medium to one part water sprayed on areas will act as a mask to the bleaching process. When the bleaching is complete, the polymer can be removed with anhydrous alcohol without affecting the print. The next step is to reapply the appropriate manufacturer's dyes. These dyes must be held over steam momentarily to set them. Finally, watercolors, inks, gouache, or acrylic can be applied for additional color and effects.

Photo retouching allows the artist to add to, delete from, and create a new image. The photograph is only a starting point, and its subject matter need not restrict the artist. The photographic image is at the mercy of the artist. ●

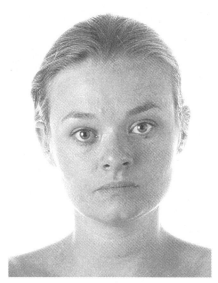

3-27.

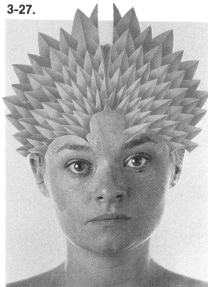

3-28.

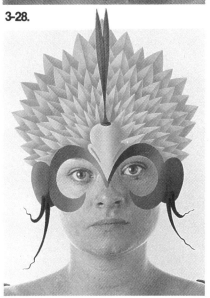

3-29.

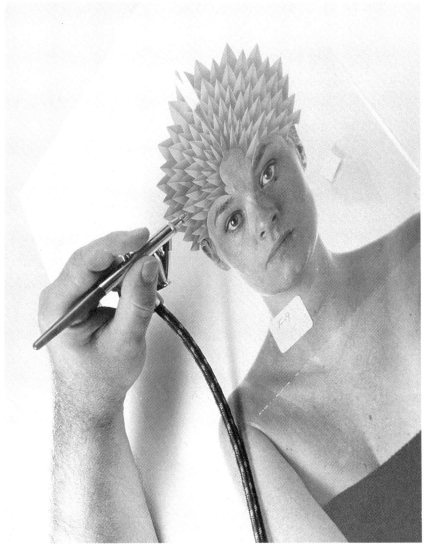

3-30.

3-27 through 3-30. Joel Jay Weissman, *Susan*, 1983. Unretouched photograph printed 16″ x 20″ on fiber-base paper and dry-mounted. The drawing for the headdress and wings was developed on tracing paper over the photograph. The acetate stencils were then cut over the tracing paper drawing and placed on the photograph. Black and white gouache were used to mix four different values of gray, which were airbrushed onto the print. The completed image was rephotographed, printed to 16″ x 20″, sepia-toned, and hand-colored with Marshall's oils.

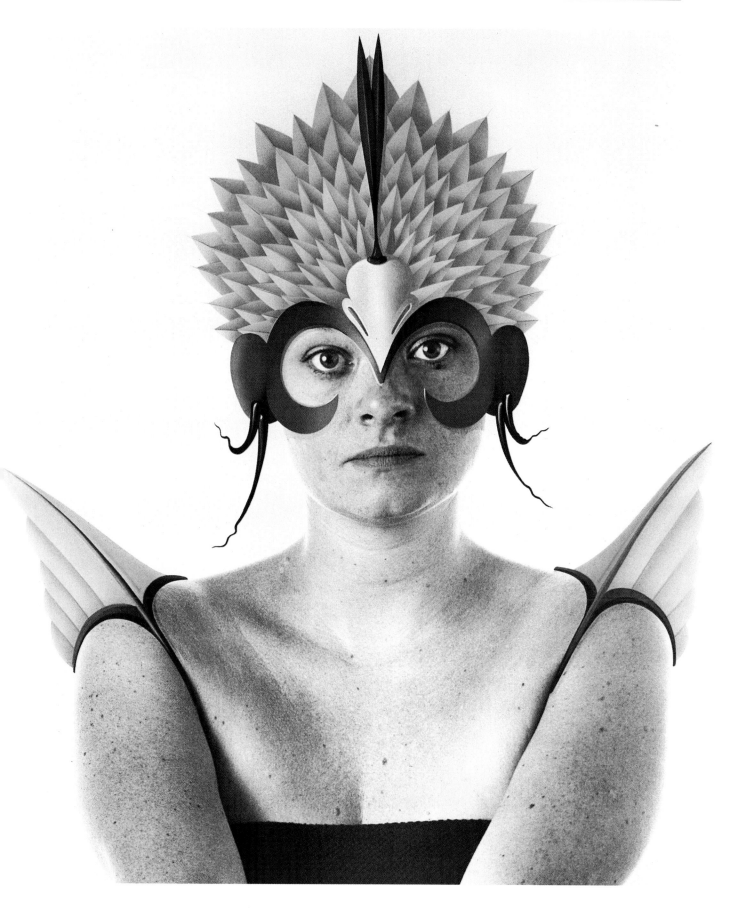

3-31. *Susan.*

3-32. Ellen Denuto, *Self-Portrait at Christmas*, 1982. Unretouched black and white photograph on resin-coated paper, 8″ x 10″.

3-33. *Self-Portrait at Christmas*. Background removed with Air-Opaque; image colored with transparent dyes.

3-34. **Paul Bond**, *P-51D*, 1982. Offset litho print of airbrush illustration. Acrylic on paper, 20″ x 30″.

Printmaking

The airbrush can be used to create a print, enhance an existing print, or both. Lithography, etching, and silk screen all lend themselves to airbrush technique.

In lithography the airbrush is used to spray liquid tusche onto a stone or plate. Plates are preferable because they are portable and easy to store, and are more durable and less expensive than stone. Both stencils and vinyl friskets can be used on plates or stones, but any adhesive residue must be thoroughly removed. Opaque paint can be sprayed onto sheets of Mylar and used as a positive or negative to place over photosensitized litho plates. Mylar is well suited for this because it will not tear or stretch during handling and thereby affect registration. These plates are exposed to light through the Mylar blockout, developed, and printed. This process can be used for plates on either a flatbed or offset press. This same process is used to separate colors; a different Mylar blockout is made for each color.

Another way to use airbrush technique in lithography is with the transfer paper process. Litho transfer paper allows the image to be developed away from the print shop (in the airbrush studio) and later transferred to the stone or plate on which it will be printed. This material is available in several types of surfaces and sizes and can be used on plates or stones. The surface will not hold up to adhesive-backed frisket films, so it is recommended that a 5-mil acetate be used for stenciling.

In etching, a number of spray processes can utilize an airbrush. An etching plate can be completely covered with an acid-resistant coating such as enamel or asphaltum, either with an airbrush, spray gun, or spray can. After the coating dries, the image is scratched through with a needle, bitten into the plate with acid, and then printed. By airbrushing the material onto the plate rather than brushing it on or applying it

with a spray can, the artist has the opportunity to work with controlled dot patterns. Gradations can be achieved by varying the size of the dots and the distance between them. This is done by cutting down the air pressure for stippling, changing head assembly sizes, or using overspray. A negative image can be developed by spraying the acid resist directly onto the plate either freehand or with stencils. A positive image can be achieved with a sugar-lift process: make a solution of two parts corn syrup to one part black poster paint and reduce with water to a sprayable consistency. To create an image, spray the solution directly onto the plate; allow it to dry, and cover it with a thin coat of etching acid-resistant material. The sugar lift is water-soluble and therefore dissolves in a water bath. A heavy coat of resist material would prevent this dissolution. The black paint is added to the sugar lift to make it visible. After the acid-resist dries, soak in a water bath until the sugar paint dissolves. Dry the plate and place it in the acid bath to be etched. In this process the image that was airbrushed onto the plate will be the image that will be printed.

In silk-screen printing the airbrush can be used to develop a positive or negative image. The mesh size of the screen has to be fine enough to capture the dot of the spray. A negative image can be developed by spraying the blockout directly onto the screen. Use water-soluble glue as a blockout for oil-based inks and lacquer as a blockout for water-soluble inks. These combinations prevent the ink from dissolving the blockout. Use a glue blockout wherever possible because it is nonflammable, less toxic, and water-soluble, making it easy to work with and clean up. A glue blockout can be made with water-soluble glue, a small amount of poster paint to act as an indicator, and enough water to achieve a sprayable consistency. To develop a positive image, spray with a water-

soluble glue as described above. When the glue is dry, give the screen a thin coat of lacquer and allow it to dry. Soak out the glue, and the original image will open up. With this process, either water-soluble or oil-based inks can be used.

In photo silk screen, the airbrush can be used to develop images on Mylar that are then exposed onto the sensitized synthetic screen material. The airbrushed image can also be developed on paper board or canvas and photographed and processed either as a negative or a positive. This image is then exposed onto the photo screen material to develop the image.

Another application for the silk screen in airbrush technique is as a stencil. Instead of pushing the ink through the screen with a squeegee, the customary technique, use the airbrush to spray ink or any other airbrushable medium that is compatible with the blockout being used through the screen. Silk-screen stencils should be held as close as possible to the work surface, either by hand or by placing weights on the screen itself. When using a silk screen as a stencil be aware that the finer the mesh, the greater the likelihood of it clogging with medium. An advantage of airbrushing through a silk screen is that the artist can apply a variety of colors and gradations utilizing one screen. Silk-screen stencils can be used in one-of-a-kind paintings or in multiples such as printmaking and fabric design.

The airbrush can also be used in printmaking to enhance prints. Color can be sprayed into areas that have already been printed, no matter what the process. If frisketing is involved, the paper should be able to hold up to adhesive-backed frisket film. ●

3-35. **Paul Sarkisian**, *Untitled #2*, 1983. Acrylic and glitter on paper, 50″ x 38″. Courtesy Nancy Hoffman Gallery.

Mixed Media

The airbrush is well suited to mixed media because of its ability to apply various paints onto various surfaces without touching the work. This allows you to render with materials that might be incompatible if applied with a brush. An example of this type of work is Fred Danziger's *Jurassic Sunset* (Figure 3-36), which combines computer graphic printouts for the background with an airbrushed image of a lizard in the foreground.

Under the general heading of mixed media falls collage, the process of gluing one element over another to create a design. The airbrush can be used in collage to enhance the work; for example, to indicate shadows or highlights. It can also be used to develop the actual image to be collaged. The image is airbrushed on paper and arranged into a composition. The background of a collage can also be painted with an airbrush. In photo collage, photographs can be arranged and visually joined by retouching the spaces that separate them. Photographs can also be used in conjunction with other materials to make a collage. These photographs can be retouched or tinted with the airbrush. Another type of collage that has surfaced since the advent of acrylics is a paint collage. Shapes of acrylic paint are made on a sheet of glass, peeled off when dry, and glued onto the surface of the work. The airbrush can be used to establish shadows on the acrylic shapes or to paint shadows that the shapes might cast onto the background. (See Figures 3-18, 3-19, and 3-20.)

Transferring an offset printed photograph into an acrylic polymer base can be accomplished with a phototransfer method. Photographs from a magazine printed on paper with a clay base work best, as they more easily release the ink into the polymer medium. You can distinguish this type of paper from others by wetting a small area in the margin and rubbing gently with your finger. If a white residue comes off on your finger the paper has a clay base. Tape the offset photograph to a piece of glass or board. Using the airbrush, spray a coat of polymer gloss medium over the photograph.

The coat should be as thick as is sprayable with the airbrush. Allow it to dry and repeat until you have applied twenty coats. The drying between each coat can be speeded by using a hair dryer or the air from the airbrush to facilitate the evaporation of water in the medium. After the last coat is dry, remove the coated photograph from the board and soak it in water. In ten to twenty minutes the paper will separate and disintegrate, leaving the printing ink imbedded in the acrylic film.

The resulting polymer photo can then be attached to a canvas, paper, ceramic, or other backing, using gel medium as the adhesive. The film can be stretched before adhering by warming it in hot water or with a hair dryer and then pulling it into the desired shape. It must be glued at this point, as it will otherwise eventually return to its original shape. After the mounting is dry, the surface can be tinted or painted in areas with an airbrush, painted over in an impasto manner, or used as a sort of photo collage in combination with other materials. ●

3-36. **Fred Danziger**, *Jurassic Sunset*, 1982. Airbrushed acrylic on computer-generated print.

Fabric

The airbrush is ideal for decorating fabric because of the variety of effects that can be achieved. Some textile media come prereduced for use in the airbrush, whereas others must be reduced with water or alcohol before spraying. (Follow manufacturer's instructions.) Generally, it is easier to airbrush a fabric before it is sewn into a garment, particularly if the design is to be an overall pattern. When images are airbrushed onto readymade garments such as T-shirts, the placement of the image is more critical. Gently stretch the fabric to remove any wrinkles and place cardboard under it in case of bleed-through. With stretch garments such as dance leotards, the design should be applied while the garment is worn because of the image distortion that would otherwise take place when the material is stretched (Figure 3-37).

Designs can be applied freehand (see Figure 2-17) or stencils can be used for hard-edged designs. Stencils for fabric painting may be cut out of adhesive-backed frisket film for one-of-a-kind pieces (the adhesive will pick up lint from the fabric, so it can be used only once) or thick acetate when repeated use is desired. Weigh down acetate stencils to keep the edges of the design close to the fabric. Do not cut stencils on the fabric. For more elaborate or photographic designs silk screens can be used. Spraying textile media through the silk screens will result in subtle blends and effects. Found objects such as lace, feathers, and leaves can be sprayed through and around as positive or negative stencils. Fabric resists such as wax can be employed with airbrush technique for unusual results. The resist can be used simply as a sort of stencil to define certain areas and keep the color from spreading. Wax can be used to achieve a batik effect. The fabric is covered with melted wax and allowed to dry. It is then rolled up to crack the wax and finally sprayed

3-37. Tony Gregory, *Icarus*, 1983. Freehand airbrush, fabric dye on dance leotard. Model: Penny Mallot.

with color. Fabric can also be tied or knotted and sprayed for a tie-dye effect.

Mistakes made with fabric paint, textile inks, and dyes are not correctable. Make sure your hands are clean, as smudge marks are permanent. These media must be heat- or steam-set for washability and to prevent fading. Times and temperatures vary among manufacturers. (See *Water-based Permanent Media—Fabric Paints* and *Fabric Dyes*, in Part II.) ●

Restoration

The airbrush has been used for years in the restoration of art and antiques. It allows the restorer to imitate the original surface, facilitates color blending and matching, and will cover with an extremely thin layer. Both two- and three-dimensional items can be successfully repainted after repair.

In ceramics, airbrushing is perhaps the only way to achieve the smooth finish needed. Thinned Humbrol enamels are recommended for ceramic restoration. It is imperative that all physical surface blemishes be properly prepared for spraying. This includes fine sanding and the feathering of all edges in the area to be repaired.

The airbrush can also be used to restore colors that have faded, while retaining the original brushstrokes. Only a small amount of paint need be put on with an airbrush for satisfactory results without filling in or covering over delicate brushwork.

There are two schools of thought in the repair of art and antiques. The first (usually applied to paintings and sculpture) is that of the conservator; it considers it best to do the least amount of repair that will salvage as much of the original material as possible. Figure 3-38 shows a conservator airbrushing paint onto several small repaired areas of an antique doll. Powdered pigments are mixed into the clear acryloid to match the color and then thinned with xylene for use in the airbrush. The second approach to repair is restoration, the main objective being to make the object appear as it did in its original state. The piece to be restored is sometimes totally rebuilt and rendered anew with no consideration to saving the original finish. Restoration is most often applied to antiques such as furniture, automobiles, carousels, and carousel figures (Figure 3-39).

Antique dolls can be restored with a variety of media when there is no concern for saving the original finish. One method is to begin by using a varnish remover to strip away the original varnish, which has in all likelihood yellowed and cracked. After making any needed repairs (with epoxy putty), the eyes are masked out with aluminum foil and sprayed with a water-base opaque ceramic stain. These nonfiring colors are very opaque (easily covering repaired areas); they thin with water and dry to a mat finish. When the ceramic stain is dry, two or three coats of mat ceramic finish are sprayed on and a coat of paste wax is rubbed in to provide a good sheen as well as a slight amber color to the finish for an aged effect. Other materials can be used in doll restoration if they are compatible with the surface and produce the desired effects.

Airbrush technique is important in conservation and restoration because it enables a variety of media to be applied without the artist touching the surface of the work; moreover, a variety of effects can be obtained without creating brushstrokes. ●

3-38. Doll restoration by conservator **Maureen Russell Neil**, Mario's Conservation Services, Washington, D.C.

3-39. Carousel deer restored by **Maureen Russell Neil**. Subtle blending of enamels achieved with an airbrush. Collection of Noel Thompson.

Ceramics

Airbrushes or spray guns can be used to apply ceramic glazes, underglazes, and stains. Spraying these solutions allows the ceramics artist to produce a variety of unusual effects quickly for production work. A single-action external-mix airbrush is the best choice for most ceramic work, although some artists prefer the larger dual-action internal-mix brushes with a variety of head and needle sizes.

Underglazes are available commercially or can be mixed using stains or pure oxides. They should be strained through at least a 200-mesh screen before spraying. Spray the greenware with a few light coats of water to aid absorption of the glazes. Using an air pressure of 30–40 psi, spray on the light-colored underglazes first, working toward the darkest. Using the airbrush to apply underglazes makes it possible to apply many different colors before firing. It is a good idea to make a set of test tiles to check the spray effect and color combinations.

Spraying the piece while it is on a kickwheel may facilitate achieving certain patterns such as banding. In this case the wheel should be situated in front of an exhaust fan. A damp, stiff bristle brush can be worked into the wet underglaze for special effects.

Masking can be accomplished in a variety of ways. Masking tape or frisket film can be applied to the bisque, for example, if the piece is smooth and clean. Use a tack cloth to pick off excess dust. A prelimi-

3-40. Dan Gunderson, *Bedroom Ball*, 1983. Ceramic glaze, 19″ diameter.

3-41. **Thomas Hubert**, untitled, 1983. Whiteware clay, 12″. An illusory depth. Photo: Robert Lowry.

3-42. Harris and Stiles, Inc., ceramic tiles, 1983. 20″ x 26″. Individual whiteware tiles airbrushed with transparent glazes and arranged and glued to form a design. Photo: Sandy Cies.

nary drawing can be applied with pencil as a guide for applying stencils or tape. (The pencil lines will burn off in firing.) The frisket or tape may then be applied and cut for a variety of designs. The piece can be fired between glazes to achieve some depth between colors or to facilitate certain masking procedures. After tape or frisket film is taken off, any adhesive residue must be removed if another application of underglaze is to be applied over this same area. This is not necessary if the piece is to be fired before the next application of color.

These principles of masking and spraying can be applied to ceramic or mixed-media sculpture that can be fired. Large sculpture can be designed to be built, sprayed, and fired in smaller sections. These pieces can then be bolted or glued to-

gether as they are or in conjunction with other media. (See Figure 3-42.)

Keep the airbrush as clean as possible throughout these procedures. If clogging occurs, run a guitar or violin string through the tip.

Masks can be commercially prepared stencils, found objects such as leaves, or homemade from resin-coated photographic paper. This paper holds up to water and is pliable enough to follow the form of the piece. Color can be sprayed through the cutout of the stencil, resulting in a positive image, or the cutout can be attached to the work with rubber cement and color sprayed around it, in which case the image will be negative. Other masking applications include spraying through items such as lace and wire screen; drawing on the surface with a crayon before spraying the

color—the wax in the crayon will resist the underglaze and burn out in firing (see Figure 3-43); and scratching designs into the glaze with a sharp tool (*sgraffito*) before firing, being careful not to push too hard, and then using an airbrush to apply gloss, satin, or mat glazes diluted to the consistency of cream.

After firing, an air eraser can be used to etch designs into the piece or remove areas of glaze or color. At that point further coloring can be achieved on the outside only with unfired stains, acrylic paint, enamels, or lacquers.

Glazes tend to be abrasive on the airbrush, as they contain silica. Spare tips and needles should be kept in reserve. Keep in mind that spraying ceramic glazes presents a health hazard and should be done only with proper precautions. ●

3-43. Lynn Turner, one-cup teapot, 1981. Teapot 9″ x 3″ x 4½″ x 4″; cup 4″ x 2½″ x4. Design developed with wax resist and sprayed over with ceramic glazes.

Sculpture

The process of using spray technique on three-dimensional surfaces is much the same as on two-dimensional surfaces. The selection of the medium to be applied is determined by the surface and the artist's intent. As in all spray technique, the toxicity and flammability of the material being sprayed should be considered.

A unique problem that faces some sculptors is that their work is frequently placed outside, where it is affected by the elements. Both the colorfastness and durability of paint should be considered as well as the proper preparation of the surface to ensure longevity. Unlike in painting, where the image is developed with the airbrush, the function of spray in sculpture is to enhance the image.

Spray technique can also be applied to sculpture in the form of sandblasting. Surface preparation of metal or glass, modeling of stone or wood, or the manipulation of painted surfaces are all possibilities. (See Figures 3-46 and 3-47 for examples of sandblasted art.) Sandblasting equipment is available in a vast range from industrial units using 150 cfm at 100 psi down to air erasers using 2–3 cfm at 30 psi. The selection of sandblasting equipment should be based on the scale and composition of the sculptural material. Abrasives come in various particle sizes (grits). As a rule, the more delicate the application, the smaller the grit to be used. A moisture trap on the air source is important, as the abrasive powder will tend to stick together in high-humidity conditions. If a moisture problem persists, add to the abrasive diatomaceous earth or heated and dried cornstarch. In Howard and Allison Zoubek's window, *Frogs*, the relief is achieved with an air eraser. (See Figures 3-44, 3-45, and 3-46.)

The materials that can be used as a resist in sandblasting are adhesive-backed shelf paper and rubber and metal stencils. For multiples, use metal or rubber stencils, as their edges will hold up to repeated use without distorting the image. Sandblasting generates large quantities of dust and can cause a dust explosion in confined quarters. Eye protection as well as a respirator is necessary. When working with large sandblasting equipment, be sure to wear protective apparel (heavy-duty gloves, hood, and face shield).

Ceramic sculpture that is to be fired can be airbrushed with ceramic glaze (Figure 3-48). After the piece is through its final firing or for work that does not require firing, an airbrush can be used to apply acrylics, enamels, or lacquers. These paints can also be sprayed on sculpture made of plaster, fiberglass, metal, Plexiglas, rubber, latex, or wood. Consideration should be given to proper surface preparation as well as the compatibility of the materials being used. ●

3-44. Howard and Allison Zoubek, *Frogs*, 1983. Glass, 28″ x 18″. The glass is first covered with adhesive-backed contact paper. The design is then drawn on tracing paper, which is sprayed with adhesive and applied to the surface. The areas to be sandblasted are then cut out and sandblasted.

3-45. *Frogs*, detail. The contact paper acts as a resist to the sand and allows the artist to maintain crisp edges with which to develop the design.

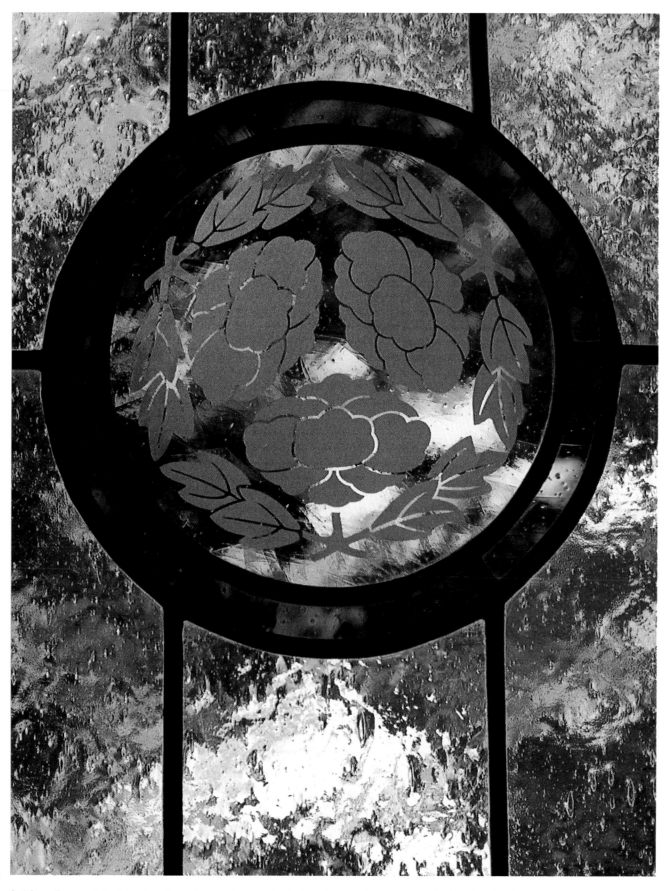

3-46. *Frogs*, detail. Installation view of finished window. The colors are created by the background coming through.

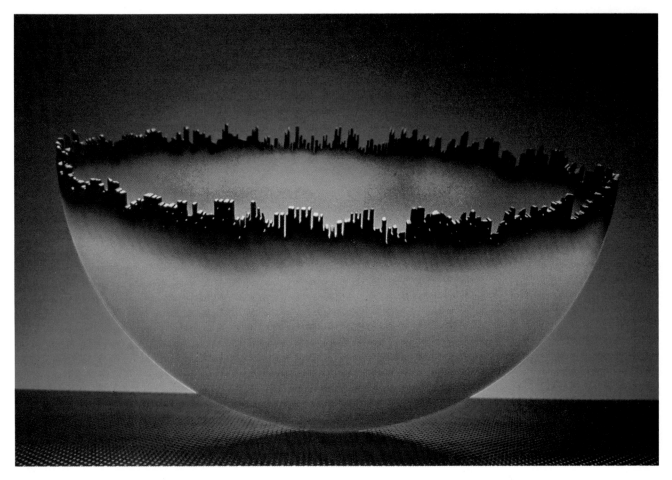

3-47. **Jay Musler**, *Cityscape*, 1981. Airbrushed oil paint on sandblasted glass, 18″ x 8″.

3-48. Rosemary Ishii MacConnell, *Sable Landscape*, 1983. Airbrushed background with stenciled landscape on porcelain, 14″ x 12″. Courtesy Bruce Cocker.

Patina

Airbrushes or other spray equipment can be used to establish a patina on bronze sculpture and to re-patinate repaired areas. Stencils can be used to achieve designs or decorations. A brownish gold surface will result when the piece is heated and sprayed with ferric nitrate. Ammonium sulfide is also used and will establish a black patina if the bronze is heated first and a brown patina if it is not. Sulfurated potash will give results similar to ammonium sulfide. These solutions when sprayed will give a smoothly finished patina void of the variations that a bristle brush may cause. The use of spray technique also allows access to the recessed and hard-to-reach areas. These materials are toxic; precautions should be taken to protect eyes, skin, and lungs.

All acids are toxic when sprayed, and proper precautions should be taken. Ventilation is mandatory. Wearing a carbon filter respirator, protective clothing, and gloves is recommended. Goggles should also be used to protect the eyes. These acids are available at chemical supply houses and art and sculpture supply stores. ●

Jewelry

Jewelry can be viewed as small sculpture and therefore be painted rather than enameled or left in an unfinished state (Figure 3-49). The only paint that is suitable for the surface of jewelry is automotive paint because of its hardness and durability. The only way to apply it is with a spray apparatus. Taking into consideration the scale of jewelry, the spray apparatus must be an airbrush. Automotive paint can be sprayed through either an internal- or external-mix airbrush depending on the size of the dot pattern required.

Although it is possible to use any of the three types of automotive paint—acrylic enamel, acrylic lacquer, and polyurethane—acrylic lacquer is preferred because of its quick-drying characteristics, the extensive color line, the specialty paints available, its transparency, and the depth of finish achievable. Depending on the type of paint and manufacturer, the reducer, the amount of reducer, and cleanup solvent change. Refer to the manufacturer's instructions. There are additives that vary the hardness, drying time, and sheen (shiny to wet; never mat). Once dry, automotive paints are colorfast, durable,

3-49. Susan Kingsley, *Pearly Pink Moment Pin*, 1982. Copper, brass, silver, with acrylic lacquer, 2″ x 1½″ x ¾″. Photo: Lee Hocker.

and hard but can be altered with an air eraser, sandblaster, or etching tool.

Traditional fired enameling can also be achieved with an airbrush by dissolving the powders in a liquid base coat and then spraying onto the piece of jewelry.

No matter which of these materials is used, the surface must be properly prepared. Sandblasting the surface will provide a tooth for paint and enamel. The surface must then be cleaned with steam, ammonia, or a metal prep solution. Refer to *Industrial and Automotive Paints*, in Part II, for more information and precautions. ●

3-50. Gregg LeFevre, *Domaru*, 1983. Reinforced cast paper and acrylic, 50″ x 56″ x 4″. Courtesy Sheila Nussbaum Gallery.

Imitation Airbrush

3-51. Scott Lewczak, computer-generated airbrush effect with Artronics computer, 1983. 12″ x 12″.

The popularity of the airbrush "look" has engendered several new methods of achieving it without actually using an airbrush. Gradient color sheets are available in coated and uncoated stock, as transparent acetates and opaque paper sheets of various sizes and colors (Pantone offers twenty-four) and are manufactured with and without an adhesive backing. Each sheet of continuous tone color (no dot pattern) covers a density range of from 100 percent to zero.

Among the disadvantages of using this material to imitate airbrushed art are that the gradations of color modulate in only one direc-tion, it is not possible to render three-dimensional shapes or blend a variety of colors, and the artist is limited by the size of the sheet. The entire sheet must be used for the full range of color gradation where-as the airbrush can achieve this effect in an area of any size. This material is best used in conjunction with airbrush technique either by airbrushing or painting on it and using it as a background. It is also well suited to a commercial paste-up application.

Another way to imitate the airbrush "look" is by computer. Several manufacturers offer computer models with an airbrush mode. An artist can generate dot patterns similar to that of an airbrush, but at the present time the dots are much larger and, rather than being round, are square in shape. These factors prevent the smooth transition of color line and value achievable with an airbrush. The images produced by this technique are monitored on a color video screen and can be photographed (Figure 3-51) or printed out on paper for a hard copy. Both of these surfaces can then be painted on and reworked with an airbrush or left as is. See Figure 3-36 as an example of an airbrushed computer painting. ●

Conclusion

More airbrushes are being used today than ever before and are being utilized in an ever-growing number of applications. New and unusual applications of airbrush technique will constantly arise from experimentation with the airbrush as well as with grounds and media not usually associated with airbrushing. There is no reason to assume that any one particular medium, ground,

or method need be adhered to in art. It is the artist who finds new materials and applies them to a particular application. These new materials are often discovered outside the realm of artists' materials and methods and are adapted to artistic uses or may be found in one art discipline and applied to another, as was the airbrush.

Remember that the airbrush is

simply a tool that takes media from one point to another without brush-strokes. Any reducible media can be sprayed through it and applied to any surface. The airbrush can be used for a variety of applications—decorating, painting, restoring, applying, designing, drawing, executing, enhancing, and, if using only air, dusting—to name just a few. ●

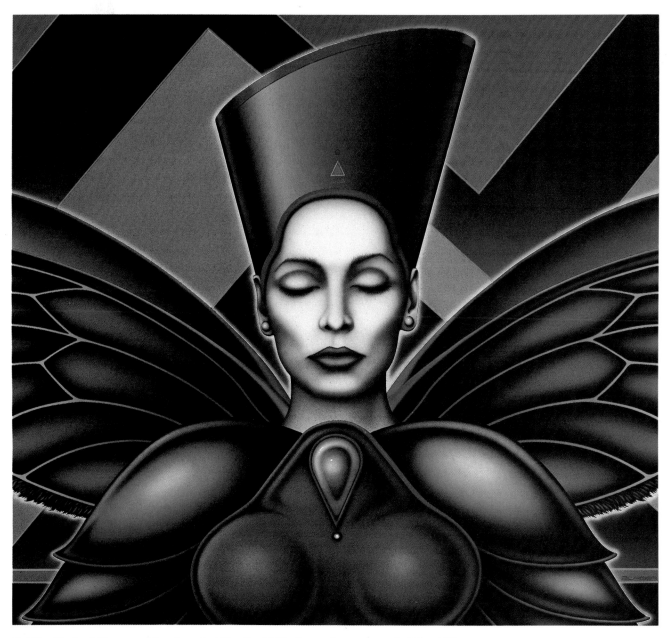

3-52. **Robert Burger**, *The Angel of Death*, 1983. Gouache on board, 19″ x 19″.

Glossary

acetate. Transparent plastic, available in sheets or rolls, used in airbrushing as stencil material (plain acetate) or painted on (treated or wet-media acetate).

acetone. A strong solvent used as a cleaning agent.

acrylic. A type of synthetic artists' paint.

alkyd. A fast-drying, resin-based artists' paint.

biological illustration. Rendering of organic things.

bleaching. The chemical removal of color.

bottom feed. 1. The system of liquid transfer relying on the Bernoulli effect to draw liquid from a reservoir mounted under the airbrush; 2. an airbrush employing that system of liquid transfer.

cel. Individual acetate sheet used in animation.

cfm. Cubic feet per minute, a unit used to measure volume of air.

chroma. The intensity or brightness of a color.

cold-press surface. A medium surface developed for illustration board by cold-pressing rollers.

collage. A composition that is pasted together.

color cup. A small reservoir for feeding medium to the airbrush.

compressed air. Air under pressure.

compressor. A machine designed to produce and sometimes store air under pressure.

cross section. A rendering that illustrates an object cut through at right angles to its longest axis.

cut. The area removed from a frisket or stencil.

cutaway. A type of illustration showing the interior and exterior of an object at the same time.

dual action. 1. A method of triggering an airbrush whereby depressing the trigger delivers air and drawing back on the trigger delivers the liquid material; 2. an airbrush so operated.

dye. A nonpigmented aqua medium.

emulsion. The light-sensitive coating on photographic paper.

external mix. The type of airbrush wherein the liquid is atomized outside the airbrush head.

fan. The width of the spray produced by a spray gun.

fogging. Clouding of improperly applied varnish.

freehand. Airbrushing without the use of stencils.

frisket. Adhesive-backed mask that protects the covered areas from airbrush overspray.

frisket film. Transparent, adhesive-backed masking material that is cut while in position.

frisket knife. A thin-bladed razor knife having a tip with an extreme angle and either a fixed, swivel, or multiple blade.

frisket paper. Translucent, adhesive-backed masking paper that is cut while in position.

gel medium. A thickened binder or vehicle for paint used to alter its consistency; usually used for impasto effects.

gesso. A white, plasterlike coating used to prepare a canvas or panel for painting.

ghosting. 1. The illustrative technique of superimposing one image over another, often used to show both the internal and external views of an object simultaneously; 2. creating a fade-out around an object.

glaze. A transparent paint film.

gloss medium. A medium that dries to a shiny finish.

gouache. An opaque watercolor.

gradation. A gradual change of value, chroma, or hue.

gravity feed. 1. The system of liquid material transfer that uses gravity to transfer liquid material into an airbrush from a reservoir mounted above the airbrush; 2. an airbrush employing that system of liquid transfer.

ground. The prepared surface to which paint is applied.

hard edge. The crisp edge developed by airbrushing over friskets, stencils, and masks.

highlight. In airbrushing, a bright punctuation of reflected light usually created by spraying concentrated areas of white paint.

high sheen. In airbrushing, simulating the appearacne of reflected light by spraying lighter colors or white.

hot-press surface. A paper that is finished with pressure from hot rollers to give it a smooth surface; used in illustration board.

hue. The name of a color, such as red or blue.

impasto. Thick, heavy painting done with brush or palette knife.

ink. Nonpigmented aqueous medium.

internal mix. The type of airbrush wherein the liquid is atomized inside the airbrush head.

light source. The place or point from which light originates.

liquid frisket. A removable liquid masking material applied freehand.

mask. 1. A protective filter covering for the face; 2. to cover areas of a surface not to be painted; 3. a covering used to protect areas not to be painted.

medical illustration. A rendering of predominantly organic or health-related images.

medium. A binder or vehicle into which color pigments are mixed.

mixed media. Combination of materials used in a work of art.

modulate. To regulate or vary the value or color.

moisture trap. A filter for removing water from air.

monochromatic. Of or having one color.

mural. A painting executed directly on a wall.

oil paint. Artists' paints made of pigments dispersed in oil.

opaque medium. Nontransparent paint (gouache, oils, acrylics).

overlay. A transparent sheet laid over artwork as a ground to be worked on.

overspray. 1. To spray over artwork to alter color or effect; 2. the atomized material that escapes the directed spray.

paint. A mixture of medium and pigment.

perspective. The art of creating the impression of depth through the use of converging lines and gradation of tone or color or both.

photo emulsion. A light-sensitive coating.

pigment. A material used as a colorant in paint.

psi. Pounds per square inch, a unit used to measure pressure.

reducer. A thinning agent.

reflected light. Light that is returned to its source after striking an object.

regulator. The device that controls the psi for compressed air or gas.

render. To depict (draw, paint).

resist. A substance applied to prevent a medium from reaching the surface.

respirator. Face mask designed to filter contaminants from the air.

retouching. The alteration of a photographic image.

score. To cut into but not through.

self-bleeding. Refers to a type of compressor that automatically discharges air not consumed.

side feed. 1. The system of liquid transfer relying on the Bernoulli effect to draw the liquid material from a reservoir mounted on the side of the airbrush; 2. an airbrush employing that system of liquid transfer.

single action. 1. A method of triggering an airbrush whereby depressing the trigger delivers both air and liquid material; 2. an airbrush so operated.

soft edge. A diffused edge developed with an airbrush.

spray. A fine mist of air and medium.

stencil. A thin sheet in which shapes or patterns are cut, through which paint, dye, or ink is applied to a surface below.

stipple. 1. The controlled spraying of dots resulting in a shaded or rough-textured effect; 2. the effect of such an application.

support. The material on which the paint is applied.

tack. The degree of adhesion.

technical illustration. A highly finished rendering of mechanical objects.

template. A manufactured guide used to develop a shape.

thinner. A reduction agent, e.g., lacquer thinner.

tooth. Texture of a surface.

transparent medium. A paint, ink, or dye that permits the clear view of rendered objects over which it has been applied.

two-dimensional plane. A flat, un-curved surface; having width and length, but no depth.

value. Degree of lightness or darkness.

varnish. A final protective coating material.

vignette. The creation or extension of a background with a graduated tone.

viscosity. The degree of fluidity of a substance.

watercolor. A transparent aqueous medium.

wetting agent. A chemical used in paints to improve their flow.

Bibliography

Angles, Burr, ed. *Hints and Tips for Plastic Modeling*. Milwaukee: Kalmbach Books, 1980.

Battock, Gregory, ed. *Super Realism: A Critical Anthology*. New York: E. P. Dutton, 1975.

Caiati, Carl. *Air-Brushing Techniques for Custom Painting*. Franklin Park, IL: Badger Air-Brush Co., 1980.

_____. *Hobby and Craft Guide to Air-Brushing*. Franklin Park, IL: Badger Air-Brush Co., 1979.

Castle, Philip. *Airflow*. New York: G. P. Putnam's Sons, 1980.

Childers, Richard H., Productions. *Air-Powered: The Art of the Airbrush*. New York: Random House, 1979.

Crawford, Tad. *Legal Guide for The Visual Artist*. New York: Hawthorne Books, 1977.

Dember, Sol, and Dember, Steven A. *Complete Airbrush Techniques*. 2d ed. Indianapolis: Howard W. Sams, 1980.

English, Michael. *Three-D Eye*. New York: G. P. Putnam's Sons, 1980.

Flack, Audrey. *The Gray Border Series*. New York: Louis K. Meisel Gallery, 1976.

Fullner, Norman. *Airbrush Painting: Art, Techniques, and Projects*. Worcester, MA: Davis, 1983.

Grayson, Jean. *The Repair and Restoration of Pottery and Porcelain*. New York: Sterling, 1982.

Haynes, Michael D. *Haynes on Airbrush Taxidermy*. New York: Arco, 1979.

Knaus, Frank J. *How to Paint with Air*. Chicago: Paasche Airbrush Co., 1947.

Martin, Judy. *The Complete Guide to Airbrushing Techniques and Materials*. Secaucus, NJ: Chartwell Books, 1983.

Maurello, S. Ralph. *Complete Art Techniques*. 3d ed. New York: Leon Amiel, 1974.

_____. *The Complete Airbrush Book*. 3d ed. New York: Leon Amiel, 1980.

McCann, Michael. *Artist Beware*. New York: Watson-Guptill, 1979.

Nelson, John. *Technical Illustration*. New York: Van Nostrand Reinhold, 1979.

Paschal, Robert. *Airbrushing for Fine and Commercial Artists*. New York: Van Nostrand Reinhold, 1982.

Podracky, John R. *Photographic Retouching and Air-Brush Techniques*. Englewood Cliffs, NJ: Prentice-Hall, 1980.

Rubelmann, Stephen D. *Encyclopedia of the Airbrush*. Vol. I and II. New York: Art Direction, 1980.

Schmid, Claus-Peter. *Photography for Artists and Craftsmen*. New York: Van Nostrand Reinhold, 1975.

Seeger, Nancy. *A Painter's Guide to the Safe Use of Materials*. Chicago: School of the Art Institute of Chicago, 1982.

Slade, Alfred L. *The Airbrush Technique of Photographic Retouching*. New York: Macmillan, 1954.

Smith, Stan, and Ten Holt, Friso. *The Artist's Manual*. New York: Mayflower Books, 1980.

Tombs Curtis, Seng-gye, and Hunt, Christopher. *The Airbrush Book: Art, History and Technique*. New York: Van Nostrand Reinhold, 1980.

Vargas, Alberto, and Austin, R. *Vargas*. New York: Harmony Books, 1978.

Vero, Radu. *Airbrush: The Complete Studio Handbook*. New York: Watson-Guptill, 1983.

Index